IMAGES
of America

OHIO OIL AND GAS

IMAGES
of America

OHIO OIL AND GAS

Jeff A. Spencer and Mark J. Camp

ARCADIA
PUBLISHING

Published by Arcadia Publishing
Charleston SC, Chicago IL, Portsmouth NH, San Francisco CA

Printed in the United States of America

Library of Congress Catalog Card Number: 2007933284

For all general information contact Arcadia Publishing at:
Telephone 843-853-2070
Fax 843-853-0044
E-mail sales@arcadiapublishing.com
For customer service and orders:
Toll-Free 1-888-313-2665

Visit us on the Internet at www.arcadiapublishing.com

To Ohio's oil and gas explorers, oil field workers, and oil producers.

CONTENTS

ACKNOWLEDGMENTS

The compilation of so many historic Ohio oil field images would not have been possible without the help of several historical societies, museums, libraries, and fellow oil field historians. Judy Robinson of the Noble County Historical Society provided several oil field photographs, as well as a tour of the Thorla-McKee historic well site. Allan Doan and Terry Borah of the Bremen Area Historical Society provided access to the society's oil history archives. George Neargarder of the Auglaize County Historical Society provided several photographs and information on the Grand Lake St. Marys area. Dee Ann Horstman of the Scio Historical Museum provided several old photographs and information for the Scio oil boom. The Blosser family of New Straitsville, Cheryl, Roger, and Cameron, spent an afternoon going through historic material and provided a tour of the history center. Thanks to Prof. Robert Chase, chairman of the Department of Petroleum Engineering and Geology, Marietta College, for steering us to Reno, Ohio, oil producer Carl Heinrich. Not only did Heinrich provide some great photographs and historic information, he also helped identify oil field equipment in many photographs. Paul Wolfe, professor emeritus, and Bill McIntire of the Department of Geological Sciences, Wright State University, Dayton, provided some more recent photographs of an Ohio seismic operation. Bob Crego of Ashland provided several Bremen photographs. Carol Pelz of the Grandview Heights Public Library helped with access to Somerset photographs. Susan Svec of Boling, Texas, provided access to her collection. Larry Wickstrom and Lisa Van Doren with the Ohio Department of Natural Resources, Division of Geological Survey, provided access to photographs and permission to use some map images. Greg Miller of the Local History and Genealogy Room of the Toledo Lucas County Public Library generously provided views in their collections. The Wood County Historical Center and Museum in Bowling Green allowed perusal of the Max Schaffer collection from the former Cygnet Oil Museum. Dale Fahle of Pemberville Depot searched his collection for oil field images. Ben Eckart, Manhatten, Kansas, allowed the use of some his National Oil Refinery material. Elliott Barrett of Black Pool Energy (Jeff A. Spencer's business partner) and Linda Spencer (Jeff's wife) helped with computer issues, scanning, and proofreading.

INTRODUCTION

Oil was discovered, produced, and marketed from wells dug in southeast Ohio, 45 years before the drilling of the famous 1859 Colonel Drake oil well near Titusville, Pennsylvania. While digging a well in the search for salt brine in 1814, Silas Thorla and Robert McKee encountered unwanted oil along Duck Creek in present-day Noble County. Enterprising peddlers gathered the oil, bottled it, and sold it as "Seneca Oil," a medicine for rheumatism, sprains, and bruises. In 1860, one of the first oil fields in Ohio was discovered along Duck Creek, approximately 10 miles southeast of the Thorla-McKee well. The discovery of the Macksburg oil field in Washington County helped ignite an oil boom in southeast Ohio. Hundreds of wooden derricks sprang up and refineries were built along the Ohio River.

During the same year, or perhaps a few months earlier than the Macksburg discovery, oil was discovered in northeast Ohio's Trumbull County. Early settlers in the area had been frustrated with oil in their water wells, a nuisance in the years before oil's value was recognized. The Mecca oil field, named for the nearby town, produced oil from the shallow depths of 40 to 60 feet. An estimated 700 wells were drilled during the first year. The Civil War brought an end to this first Mecca boom. A second boom occurred from 1878 through the 1880s when several hundred additional wells were drilled.

The first giant oil field in the United States was discovered in northwestern Ohio near the city of Lima in 1885, a year after natural gas was discovered near the town of Findlay. The discovery of the Lima-Indiana oil field set off the "oil boom of northwest Ohio," a period of land speculation and rapid oil field development that lasted over 20 years. The field propelled Ohio to the leading oil-producing state from 1895 to 1903. The field produced over 380 million barrels of oil and 2 trillion cubic feet of gas. Oil and gas development transformed a largely agricultural area into an industrial area supporting the various oil-related businesses. Northwest Ohio towns, such as Bowling Green, Cygnet, Findlay, Lima, and North Baltimore, saw rapid population growth during these boom years. As the field was extended to the south, the nation's first "over water" wells were drilled in Grand Lake St. Marys, then the largest man-made lake in the world. John D. Rockefeller's Standard Oil of Cleveland, soon to monopolize the oil refining industry, built storage tanks, pipelines, and a refinery near Lima. The Ohio Oil Company, now Marathon Oil, was organized in the state in 1887 and still maintains an office in Findlay.

The short-lived Scio oil boom of 1898 occurred in eastern Ohio's Harrison County. Over 1,000 wells were drilled in the field, roughly a quarter of which were drilled within the village itself. Scio's population grew from 900 to approximately 12,000 at the peak of the boom.

South-central Ohio's Bremen oil field was discovered in 1907 in Fairfield County, which led to the discovery of the New Straitsville oil field in adjoining Perry County two years later. As with

the Scio oil boom, Bremen and New Straitsville saw the oil fields extended to town lots. The Bremen–New Straitsville oil boom was the last significant Ohio oil boom in the early 1900s. The next significant oil boom was in Morrow County from 1961 to 1967. Hundreds of wells were drilled in just a few years, some with flow rates exceeding 2,000 barrels of oil a day. At one time, Morrow County reportedly had more oil wells than any county in the country.

Over 270,000 oil and gas wells have been drilled in the state of Ohio. The estimated cumulative production for the state since the first discoveries in 1860 is over one billion barrels of oil and eight trillion cubic feet of gas. In 2006, 952 oil and gas wells were drilled in 42 of the state's 88 counties. Well depths in 2006 ranged from 400 to 7,880 feet, with an average depth of 3,979 feet.

One

THE THORLA-MCKEE WELLS AND THE SOUTHEAST OHIO OIL BOOM

In 1814, Silas Thorla and Robert McKee operated a saltworks along Duck Creek, in what is now Noble County. While digging for the salt brine, the two men encountered oil and gas, initially a nuisance to the salt-producing operation but later bottled as Seneca Oil and sold as a medicine for rheumatism, sprains, and bruises. A second well was dug in 1816 and still exists today. The sycamore log casing is oil-permeated and exposed at the well site, which is marked with an Ohio historical marker.

The small town of Macksburg in Washington County is located approximately 10 miles southeast of the Thorla-McKee well. In 1860, a well drilled on William Rayley's farm, by a partnership of James Dutton, Alden Warren, and John Smithson, discovered oil at a depth of 59 feet. This well set off the first Duck Creek oil boom. The well location was probably influenced by evidence of an oil seep near this area of Duck Creek. Swimmers in the creek would emerge with a film of oil on their bodies. The Macksburg oil field is generally considered Ohio's first or second oil field. Cow Run oil field, southeast of Macksburg, was discovered a few months later. By 1862, there were two oil refineries along the Ohio River near Marietta. The Civil War brought an end to the initial oil boom, as many oil field workers went off to the battlefields. In the early 1870s, drilling resumed in the area and soon deeper sands were also shown to produce oil. Over 500 wells were drilled in the Macksburg area in 1886 alone and the oil field's peak production was approximately 3,500 barrels of oil per day that year. By 1900, the boom had died and Macksburg became a small, quiet farming community again.

To the north in Monroe County, over 300 wells near the town of Woodsfield, produced 55,000 barrels of oil a month during the summer of 1901. In a few years, over 60 oil companies and individuals were operating oil wells in the county. West Virginia's Sistersville Field, discovered in 1890, was extended into Monroe County in 1891. In the next 30 years, many oil fields were discovered on both sides of the Ohio River. Marietta and Parkersburg, West Virginia, both became important oil centers for the growing petroleum industry.

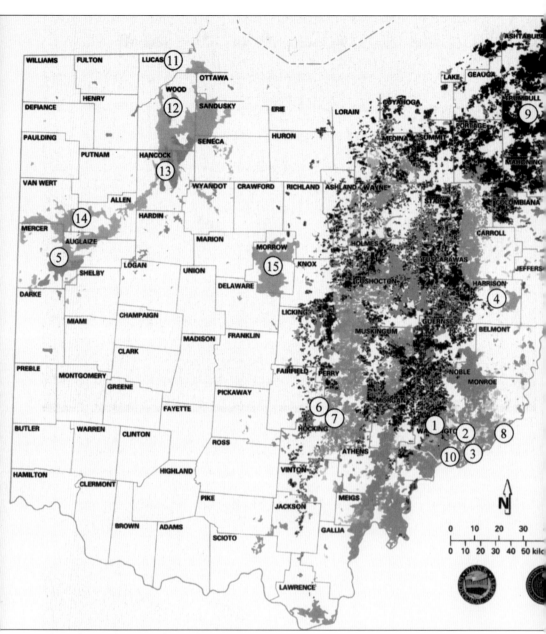

This Ohio index map shows the county outlines and key areas of oil field history. The oil and gas producing areas are shaded in black (gas) and gray (oil). Commercial oil and gas production has been discovered in 67 of Ohio's 88 counties. Seen on this map are Thorla-McKee well (1), Macksburg oil field (2), Cow Run oil field (3), Scio oil field (4), Grand Lake St. Marys (5), Bremen oil field (6), New Straitsville oil field (7), Sistersville, West Virginia (8), Mecca oil field (9), Marietta (10), Toledo (11), Bowling Green (12), Findlay (13), Lima oil field (14), and Morrow County oil field (15). (Ohio Department of Natural Resources, Division of Geological Survey.)

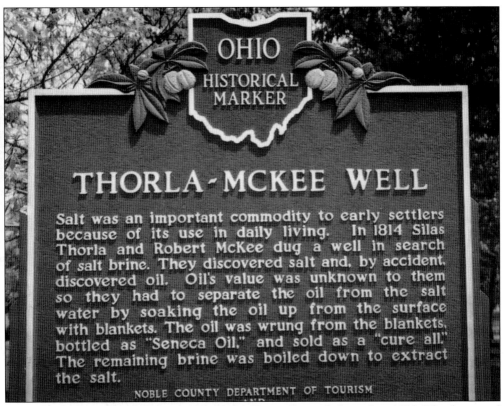

OHIO
HISTORICAL
MARKER

THORLA-MCKEE WELL

Salt was an important commodity to early settlers because of its use in daily living. In 1814 Silas Thorla and Robert McKee dug a well in search of salt brine. They discovered salt and, by accident, discovered oil. Oil's value was unknown to them so they had to separate the oil from the salt water by soaking the oil up from the surface with blankets. The oil was wrung from the blankets, bottled as "Seneca Oil," and sold as a "cure all." The remaining brine was boiled down to extract the salt.

NOBLE COUNTY DEPARTMENT OF TOURISM

The Ohio historical marker for the Thorla-McKee well was dedicated in 1992. This historical site is located near the town of Caldwell in Noble County, two miles east of Interstate 77 on State Route 78 at its intersection with State Route 564. (Photograph by Jeff A. Spencer.)

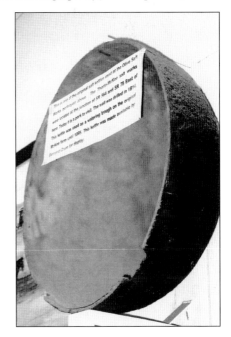

Large cast iron kettles were used to boil the salt brine at the Thorla-McKee saltworks. The kettle in this 2007 photograph, donated by Bernard Crum, now hangs in the Food Center, 110 Olive Street, Caldwell. (Photograph by Jeff A. Spencer.)

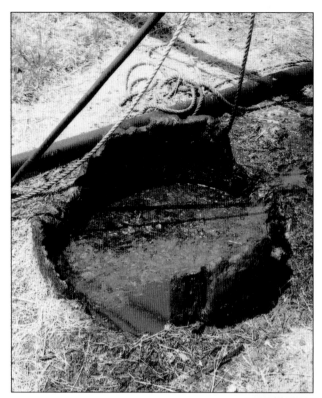

The Thorla-McKee oil well as it exists today is seen in this 2007 photograph. The oil-permeated stump is partially protected by a chain-link fence. Oil sheen is present on the water-filled stump and occasional gas bubbles attest to the continuous migration of hydrocarbons to the surface. (Photograph by Jeff A. Spencer.)

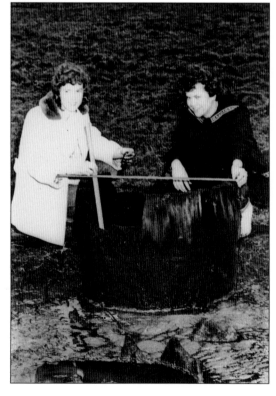

These two Belle Valley High School students, Grace Dennis Higgins and Joyce Cain, are shown measuring the Thorla-McKee well's sycamore stump casing as part of their school science project in March 1960. (Courtesy of Grace Higgins and Judy Robinson.)

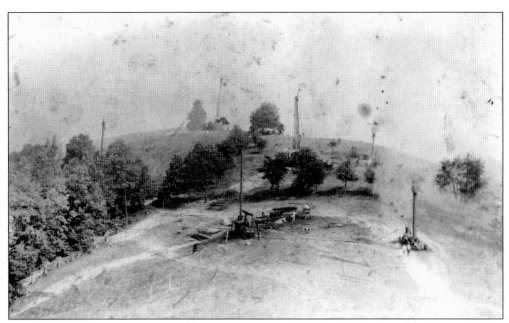

Two different types of early oil drilling rigs are visible in this oil field scene from Harron Ridge, Noble County. The middle rig in the foreground is a Star Drilling Machine. The large rig, third from the right, is a National Drilling rig, manufactured by National Supply Company. The rig to the far right shows a bucket on the smokestack, used to keep sparks from flying and igniting grass fires. (Courtesy of Judy Robinson.)

A Star Drilling Machine is in operation on the west side of Dexter City, Noble County. The Star Drilling Machine Company of Akron manufactured rigs from the 1890s to the mid-1940s, and they were very popular rigs in the early oil fields of Ohio. (Courtesy of Bob Crum and Judy Robinson.)

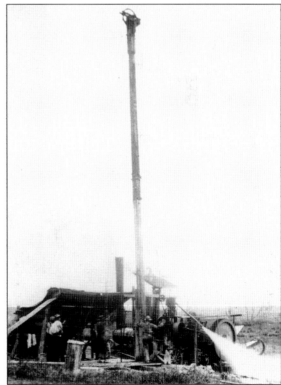

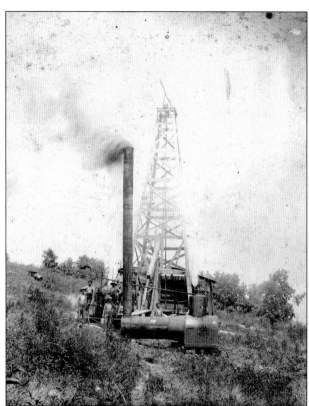

This early view of a standard rig and five of the rig workers was taken in Noble County. The steam engine does not have a house built around it yet, suggesting that the workers were posing in the early stages of rigging up. (Courtesy of Judy Robinson.)

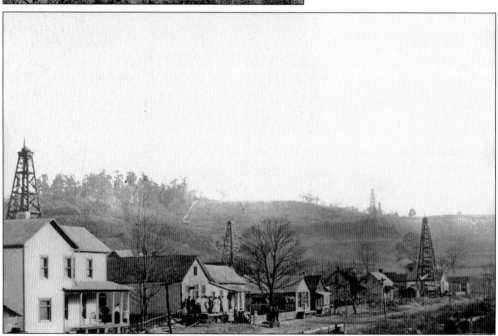

In many early oil field photographs, derricks appear very close to homes and businesses. This undated photograph shows three oil derricks in the backyards of several homes near Sycamore Valley in Noble and Monroe Counties. (Courtesy of Judy Robinson.)

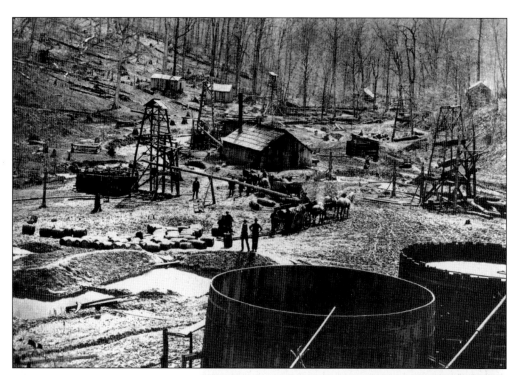

These earthen reservoirs and wooden tanks are from either the Macksburg or Cow Run oil field, Washington County. Of three copies found of the above picture, one was labeled, "Macksburg oil field, circa 1865"; the second, "Dec. 1860, NE of Morris Sawmill, Macksburg Field"; and the third, "Cow Run oil field, near Marietta, Ohio." The Macksburg oil field was discovered in 1860 and is generally considered either Ohio's first or second oil field. The Cow Run oil field was discovered just a few months after Macksburg. The picture at right is a very similar view of open earthen oil pits. This photograph was labeled "Cow Run." (Above, courtesy of Judy Robinson; right, Carl Heinrich collection.)

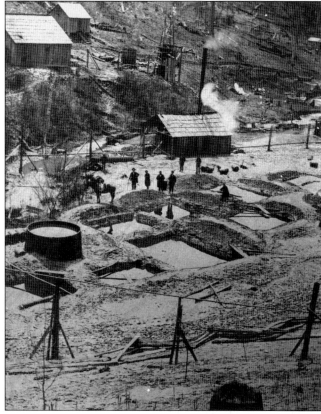

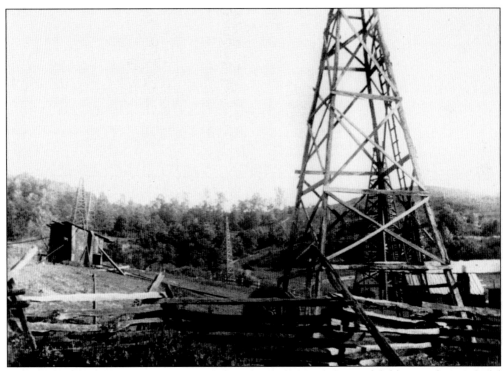

A zigzag wooden fence frames several oil derricks in the Macksburg oil field around 1865. (Carl Heinrich collection.)

An abandoned well site near the town of Macksburg, shown in this 2007 photograph, is representative of all that remains of several Macksburg oil booms from 1860 to 1900. (Photograph by Jeff A. Spencer.)

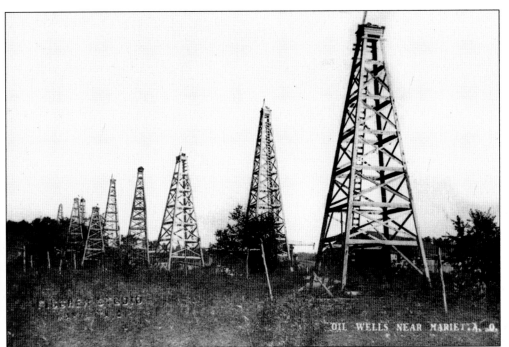

"Post hole wells," so named as they looked like fence posts in a row, may have been drilled along a fault or possibly a lease line. This photograph was labeled, "oil wells near Marietta, O." by Fischer Studio. Other photographs of this view are labeled, "oil wells near Parkersburg, WV" and, "oil wells near Boaz, WV, 1903," both areas are just across the Ohio River. (Courtesy of Judy Robinson.)

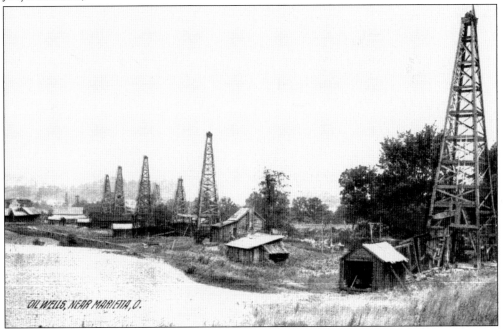

"Oil wells near Marietta" is a similar view to a photograph in Marietta College's library collection, labeled "Sand Hill, circa 1897," which is near Marietta. (Jeff A. Spencer collection.)

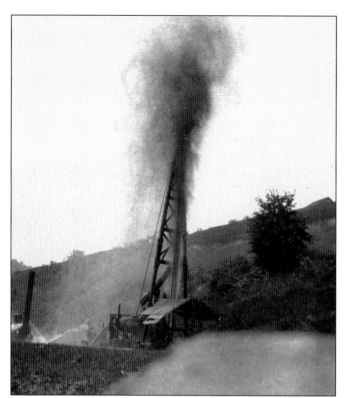

This Star Drilling Machine is in operation on the Indian Oil Company's No. 4 Hendershott well, near Dexter City. This well's objective was the Cow Run Sand, a prolific shallow producing reservoir in southeast Ohio. (Carl Heinrich collection.)

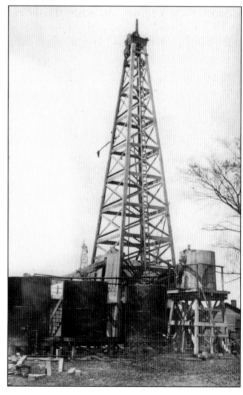

This oil derrick is in the Grandview Field, south of New Matamoras, along the Ohio River, in Washington County. The lighter-colored, wooden tank on the right side of the photograph was for water storage. The three darker-colored metal tanks were for oil. The excess water was allowed to flow into the Ohio River. (Carl Heinrich collection.)

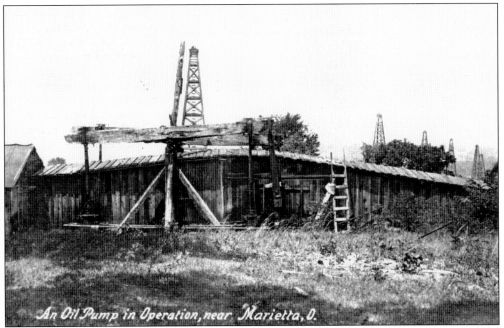

An Oil Pump in Operation, near Marietta, O.

This operation "near Marietta, O." shows an early vacuum pump used to reduce the wellhead pressure as low as possible in an effort to maintain the oil production. A vacuum pump cylinder is attached to each end of the walking beam, which is operated by a conventional standard rig type of band wheel. Similar photographs suggest that this view is probably near Boaz in Wood County, West Virginia, just across the Ohio River from Marietta. This postcard was postmarked in 1907. Oil fields do not stop at county or state lines, and many of the early oil fields straddled the Ohio River in both Ohio and West Virginia. (Jeff A. Spencer collection.)

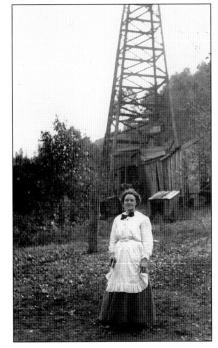

A photograph in front of an oil derrick might be good luck, especially for the owner of the property the well came in on. This woman posed in front of an early Washington County oil derrick. (Carl Heinrich collection.)

19

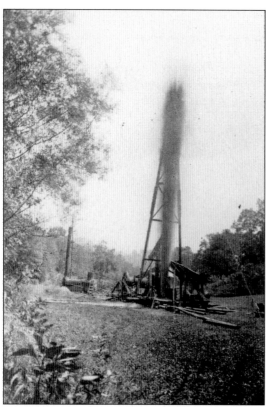

This Parkersburg rig is drilling the J. Shook No. 2 well in Washington County. The Parkersburg Rig and Reel Company of West Virginia manufactured these early and popular drilling rigs. (Carl Heinrich collection.)

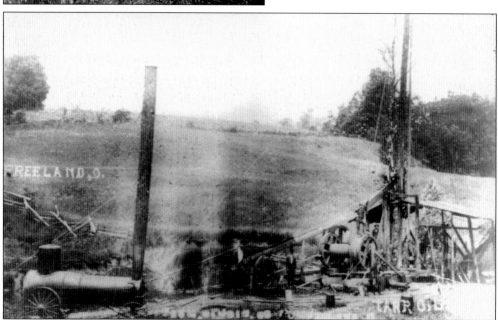

An early view of a Parkersburg drilling rig near Freeland, Muskingum County, is identified as a Tarr Oil Company operation. The boiler and steam engine are on the left side of the photograph. The sparse wooden shelter and the full-leafed trees suggest a summertime operation. (Courtesy of Judy Robinson.)

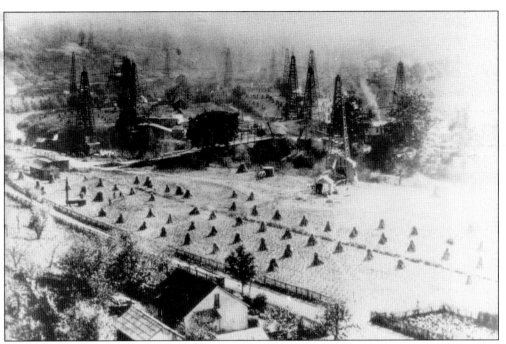

These before-and-after photographs are of the same view of the Rinard Mills area, Washington and Monroe Counties. The before view (about 1900) shows at least 15 wooden derricks. The pastoral 1974 view shows no signs of the earlier oil drilling activity. (Carl Heinrich collection.)

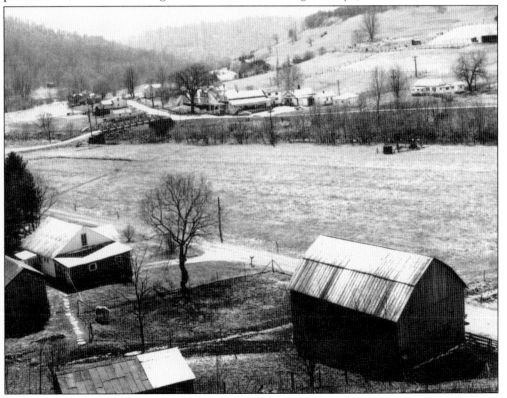

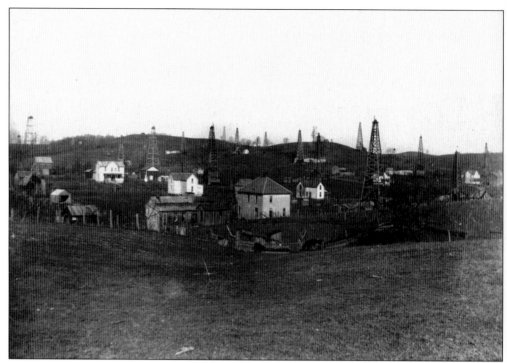

At least 16 oil derricks are captured in a hill view of northern Washington County. (Carl Heinrich collection.)

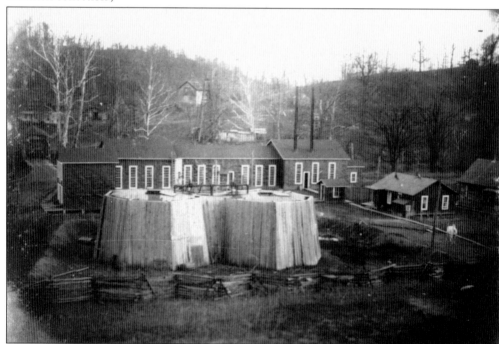

The Buckeye Pipeline Company pumping station at Patton Mills, Washington County, shows the boiler house (larger building with tall smoke stacks) and the office to the right. Iron oil storage tanks are covered with wooden boards for insulation. (Carl Heinrich collection.)

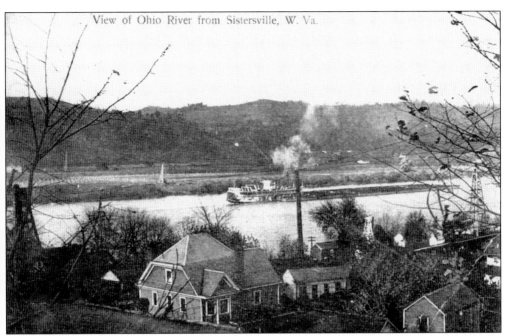

View of Ohio River from Sistersville, W. Va.

This view, taken from Sistersville, West Virginia, shows wooden oil derricks on both sides of the Ohio River. The Sistersville oil field was discovered in West Virginia in 1890. The field was extended into Monroe County, Ohio, the following year with the completion of the No. 1 Stewart well. (Jeff A. Spencer collection.)

The Reas Run oil field is located in Washington County. These wells were drilled to the Big Injun Sand, a common drilling objective in southeast Ohio and West Virginia. (Carl Heinrich collection.)

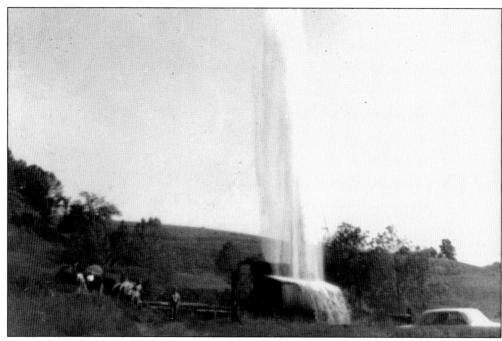

A 1967 photograph near Wingett Run, Washington County, shows a natural flowing well, producing from the fractured Ohio Shale at a depth of approximately 3,200 feet. This well is the Beck Oil Company No. 1 Myers well. (Carl Heinrich collection.)

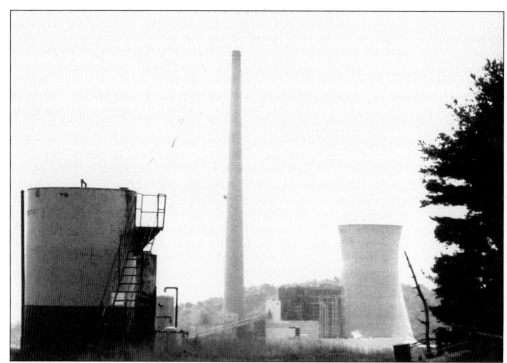

This 2007 photograph is of a modern well site that sits on a hill overlooking the Muskingum River coal-fired power plant near Beverly, in Washington County. (Photograph by Jeff A. Spencer.)

Two

THE NORTHWEST OHIO OIL BOOM

Natural gas was viewed as a curiosity and a nuisance in the Findlay area until the 1880s, when its usefulness was realized. Findlay physician and amateur geologist Dr. Charles Oesterlen convinced other residents to back the drilling of a gas well on the eastern outskirts of town in 1884. After tapping a number of small pockets of gas, a major play was tapped. The lit well created a flame 30 feet high. The thirteenth well to be drilled far overshadowed this one, making Findlay the gas capital of Ohio in late 1885. The copious flow of the Karg well could not be stopped, and the bright flame, supposedly visible for 40 miles, attracted thousands to town. The boom was on. Later the same year, Bowling Green tapped into the same gas pools; Lima followed. The story repeated in many northwest Ohio towns. However, outside of Findlay, the wells were not highly productive. Wastefulness led to a rapid depletion of the gas, and by 1889, many realized this presumed inexhaustible resource was indeed finite. By 1900, the gas boom was nearly over.

As gas escaped the underground reservoirs, oil moved upward to replace it. Lima became an early oil production center. A well completed by the Citizens Gas Company of Lima in 1885 yielded about 40 barrels per day. It was thick, foul-smelling oil though, and its value was questioned until it was shown that it could be refined into illuminating oil. By April 1887, 420 derricks rose from the Allen County fields. Other communities followed suit. Soon the field stretched from Lima north to Toledo and west into central Indiana, becoming the Lima-Indiana Oil and Gas Field with over 42,000 wells drilled by 1900. A barrel of oil fetched 75¢ around 1900. At an average of 65,000 barrels a day, this meant about $48,000 daily. Wood County became the center of production by 1900 with the largest well drilled here being the famous 1889 Ducat well—a 10,000-barrel gusher. More big producers were discovered in Sandusky County beginning in 1892. The famous Kirkbride well, near Gibsonburg came in at 20,000 barrels and then averaged 7,000 barrels daily over the next month. Unfortunately the oil boom was short-lived too, and poor management practices led to great wastage. By 1915, the boom had ended. It is estimated that 375 million barrels were produced in northwest Ohio.

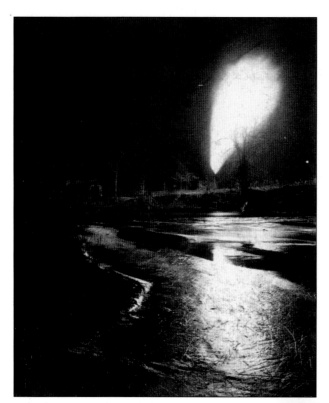

Stereoscopic views were extremely popular in the United States from the late 1850s to the early 1900s. This half of an undated stereoscopic view of the great Karg gas well shows the flared gas in a night view. The reverse of the view states, "nine wells furnish gas for heating and illuminating purposes in Findlay, the best lighted city in the county, and the flow of the wells is continuously increasing." It also mentions that the cost of these wells were "about $2,000.00 each." (Carl Heinrich collection.)

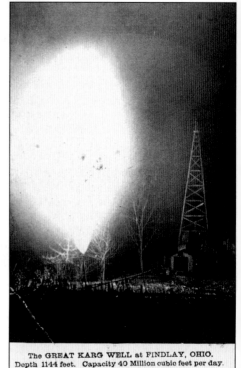

The GREAT KARG WELL at FINDLAY, OHIO.
Depth 1144 feet. Capacity 40 Million cubic feet per day.
Taken at night, by F. B. ZAY.

This postcard shows another night view of the Karg gas well with a derrick to the right. Early reports stated that the roar of the well could be heard two to four miles away. This view shows the iron pipe that extended from the well to the bank of the Blanchard River. On the banks of the river, grass and dandelions grew in January, and the portion of the river near the fire did not freeze over. Approximately 1.5 billion cubic feet of gas is estimated to have burned during the four months that the gas was flared. (Carl Heinrich collection.)

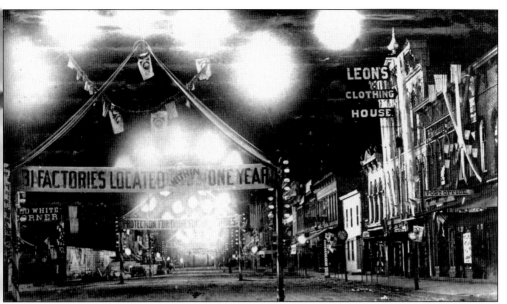

This view of downtown Findlay during the gas boom, June 1887, shows some of the 58 gas-lit arches built across Main Street in celebration of the seemingly inexhaustible supply of gas. Over 70,000 visitors attended the three-day celebration, and special trains were put in to use to transport the crowds. Many glass factories opened in the city at this time, and the population grew rapidly from 4,500 in 1884 to 25,000 by 1889. (Wood County Historical Center and Museum collection.)

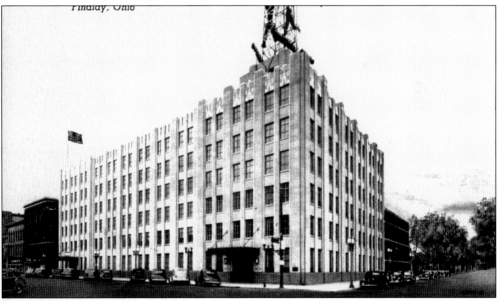

Five Ohio independent oil producers organized and incorporated the Ohio Oil Company on August 1, 1887. Henry Ernst served as the company's first president. In just a few years, the Ohio Oil Company was the largest producer of oil in Ohio with 146 wells and 21,000 acres under lease. Construction began on this office building in 1929. In 1962, on the company's 75th anniversary, the name was changed to Marathon Oil Company. Their marketing and refining group still maintains an office in Findlay. (Jeff A. Spencer collection.)

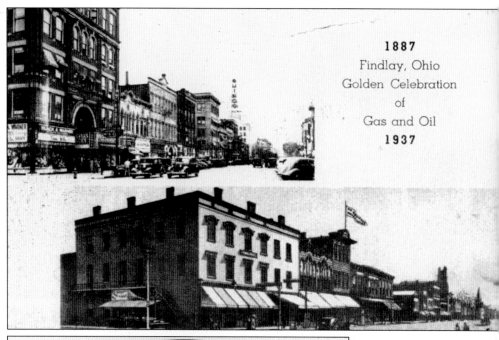

1887
Findlay, Ohio
Golden Celebration
of
Gas and Oil
1937

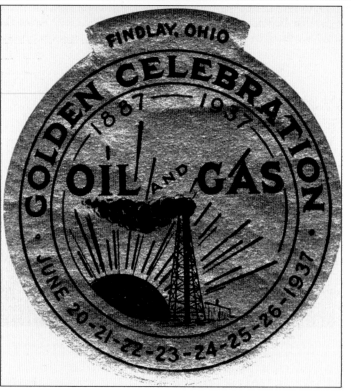

In 1937, Findlay held its Golden Celebration of Gas and Oil (1887–1937). The upper postcard shows two views of the downtown area in both 1887 and 1937. The image at left is an enlargement of a commemorative sticker of that same weeklong celebration (June 20–26). (Jeff A. Spencer collection.)

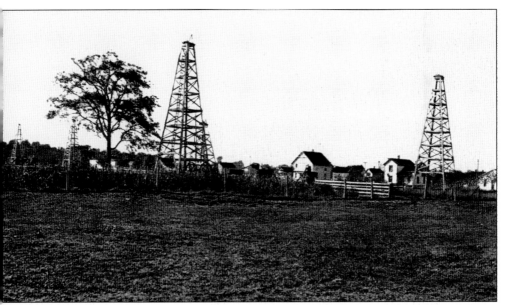

These two views show derrick scenes in the Findlay area. The first view is common of early postcards of the oil booms, which often showed "fields" of oil derricks or flowing wells. Postcard collectors refer to the period of 1907–1915 as the "golden age of postcards," as postcard collecting had become one of the most popular hobbies in the world. Postcards helped to illustrate the history, geography, and industrial the growth of the United States. (Jeff A. Spencer collection.)

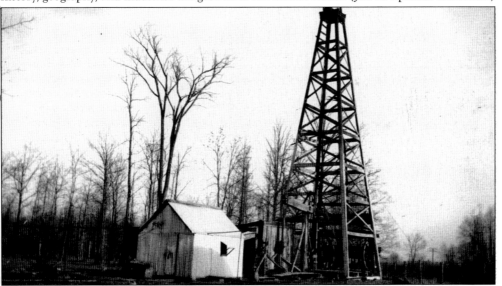

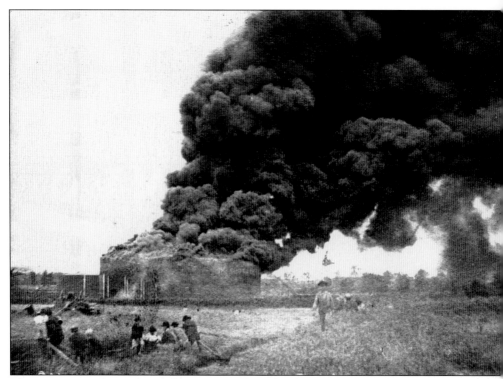

These two views show oil tank fires near Findlay. The above view, dated August 15, 1909, shows what appear to be men with a hose perhaps trying to wet down the surrounding area to prevent a grass fire. Note the other oil storage tank to the left of the burning tank. The below view is from a common postcard, titled "oil tank fire, Findlay." Dozens of spectators or workmen line the protective earthen dike. (Jeff A. Spencer collection.)

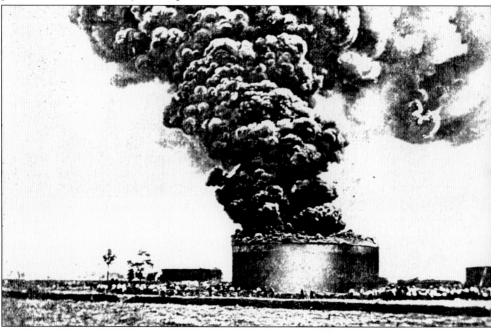

These two early postcards from Lima show multiple scenes of the town (view at right), which includes two views of a derrick; one a owing well. The below view shows both a imilar top view of a flowing well and a second ide view. (Jeff A. Spencer collection.)

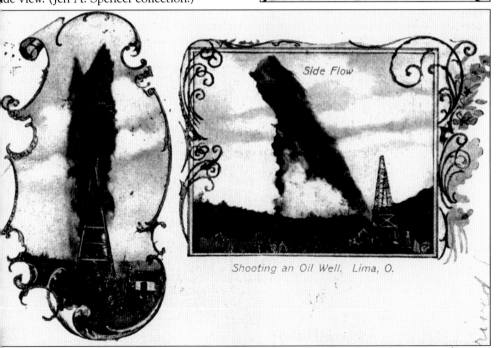

Shooting an Oil Well, Lima, O.

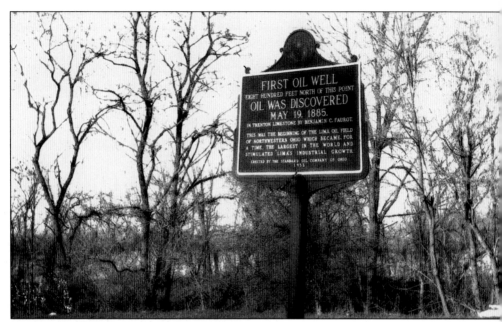

The Standard Oil Company of Ohio erected this historical marker to commemorate the Fauro[t] discovery well for the Lima oil field. Benjamin C. Faurot of Lima owned the Lima Paper Mil[l] and decided to drill a well near Lima, searching for gas or water for his mill. His well discovere[d] oil along the Ottawa River on May 19, 1885, at a depth of 1,251 feet. Faurot, with several loca[l] businessmen, formed the Trenton Rock Oil Company and, in just over a year, operated 250 wells[.] (Mark J. Camp photograph.)

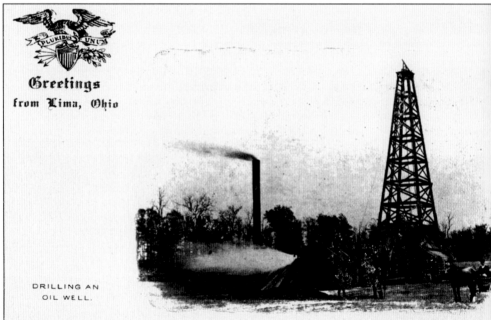

This early postcard shows a typical oil scene with the derrick, boiler room, and oil field workers[.] The "Greetings from Lima, Ohio" is capped with a patriotic United States seal. (Jeff A[.] Spencer collection.)

This burning oil well is one of the most common views of a Lima-area oil field scene used in postcards (postmarked in 1907). Note the two men in overcoats and hats posing in front of the flaming derrick. (Jeff A. Spencer collection.)

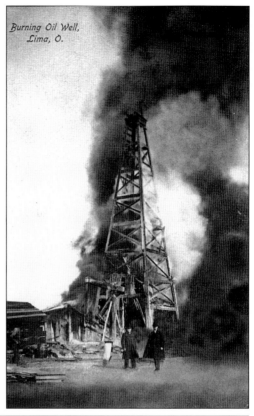

Burning Oil Well, Lima, O.

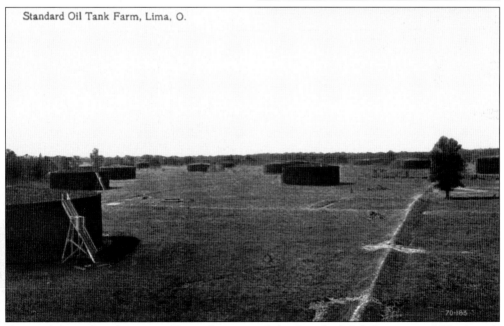

Standard Oil Tank Farm, Lima, O.

Over a dozen oil tanks are visible in this view of the Standard Oil Company of Ohio's tank farm near Lima. Standard Oil Company of Ohio also built a refinery near Lima. (Jeff A. Spencer collection.)

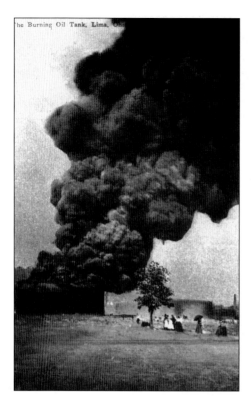

The Burning Oil Tank, Lima, O

These two postcards are views of a burning oil storage tank near Lima. Oil tank fires were not uncommon. The wooden and metal tanks were often struck by lightning. The view at left shows several sightseers fairly close to the fire. Several of the spectators appear to be women in period long dresses and carrying parasols. The night view below shows the fire reflected in water (or oil). (Jeff A. Spencer collection.)

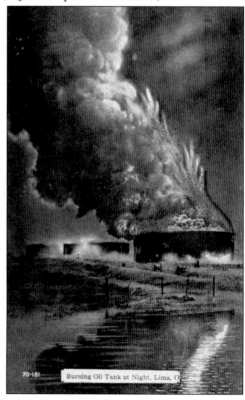

70-181 Burning Oil Tank at Night, Lima, O

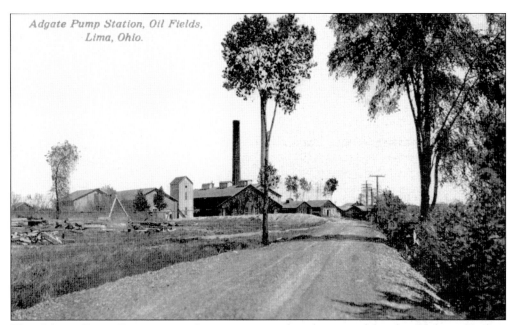

The Adgate Pump Station, near Lima, was owned and operated by the Buckeye Pipeline Company. Buckeye Pipeline Company was incorporated in Ohio as a subsidiary of Standard Oil Company of Ohio. (Jeff A. Spencer collection.)

This oil tank fire is probably in Buckeye Pipeline Company's tank farm near Cygnet or near Lima. The company opened its first 30,000-barrel steel tank farm at Lima in 1886 and began pumping oil from the Lima field. (Wood County Historical Center and Museum collection.)

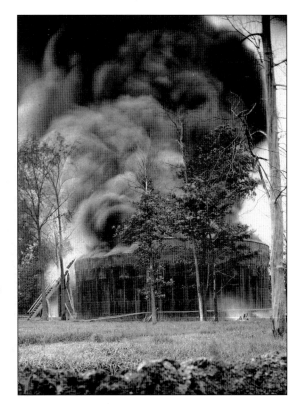

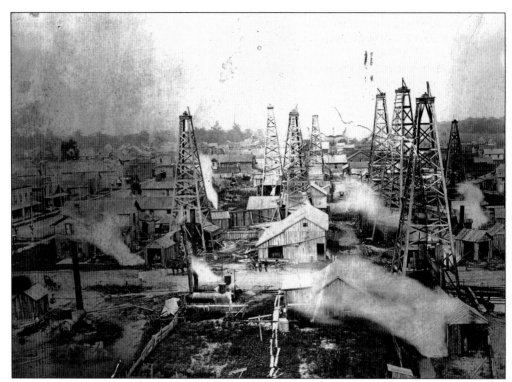

This overview of the west side of Cygnet from the 1890s shows several oil derricks with several boilers belching steam. At the height of the boom, Cygnet was the biggest oil boomtown in Wood County. The population was over 3,000 in 1890. The lower view is of Cygnet around 1885, with over a dozen derricks. (Above, Wood County Historical Center and Museum collection; below, Ohio Department of Natural Resources, Division of Geological Survey.)

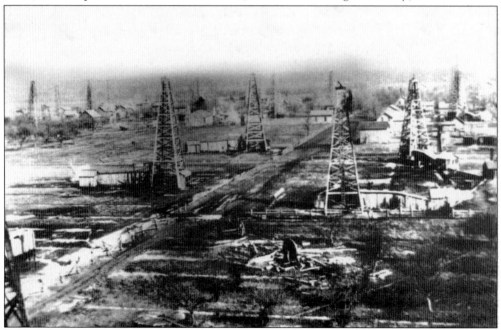

Locals pose for the photographer in front of Riley Oates's blacksmith shop in Cygnet. The local blacksmith shop was an important business in the early oil fields. Horses needed to be shod, and oil field equipment needed repairs. (Wood County Historical Center and Museum collection.)

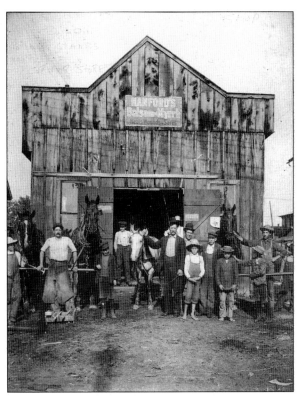

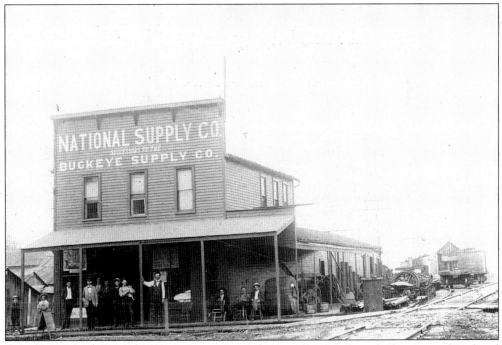

The National Supply Company store in Cygnet sits along the Toledo and Ohio Central Railroad track. National Supply Company had a store in most oil field towns. (Wood County Historical Center and Museum collection.)

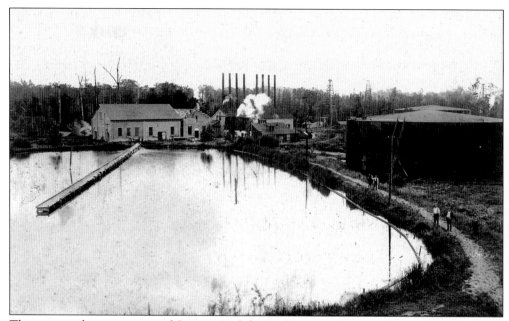

These views show a portion of Station 8 of the Buckeye Pipeline Company at Cygnet under construction in 1904. Oil was first pumped from Cygnet to South Chicago in July 1888. It traveled through an eight-inch line at one mile per hour. The Cygnet station became the largest pumping station in the world. Oil was pumped north, east, and west to refineries and other users of oil. Steam was first used to power the boilers; later coal was used. Notes at the museum say Station 8 was torn down in 1948. (Wood County Historical Center and Museum collection.)

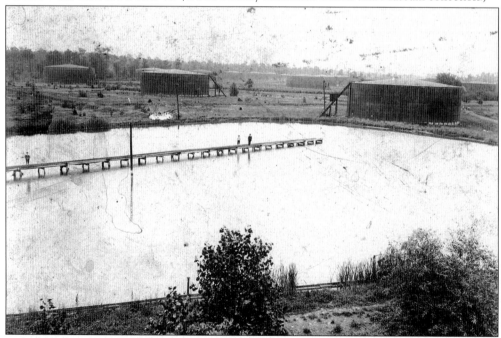

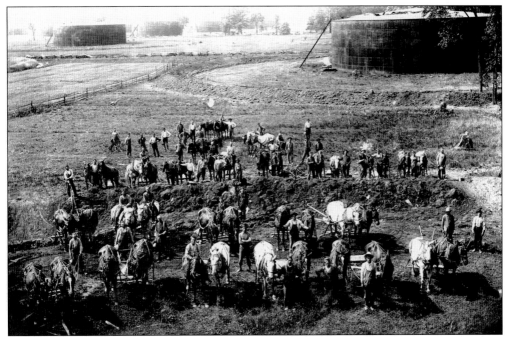

Crews, above, take a break from dike construction around oil tanks in this early-1900s photograph near Cygnet. Earthen dikes were used to contain oil tank spills and prevent fire from spreading to other tanks. Eventually 300 tanks dotted the landscape in southern Wood County, most with 30,000-barrel capacities. Below is a view of tank No. 111. The edge of tank No. 112 is in the left edge of the photograph. (Above, Wood County Historical Center and Museum collection; below, Jeff A. Spencer collection.)

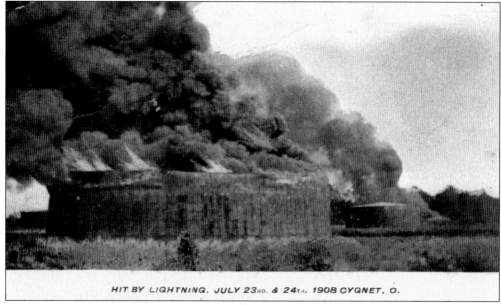

HIT BY LIGHTNING. JULY 23RD. & 24TH. 1908 CYGNET, O.

These two postcard views show a daylight view and a night view of a 1908 tank fire. The daylight view states the cause as a lightning strike. There is a difference of seven days in the dates on the two cards, possibly two different fires. (Jeff A. Spencer collection.)

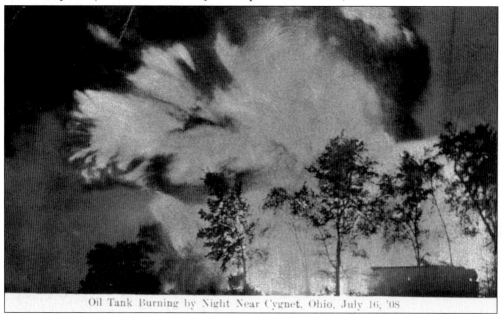

Oil Tank Burning by Night Near Cygnet, Ohio, July 16, '08

This is another view of an oil tank fire (tank No. 131), probably in the Cygnet oil tank farm. (Wood County Historical Center and Museum collection.)

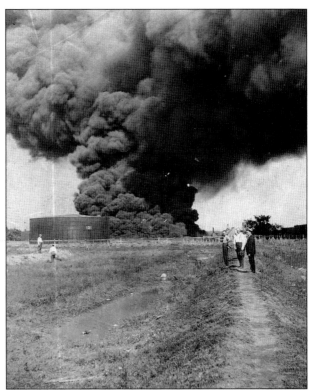

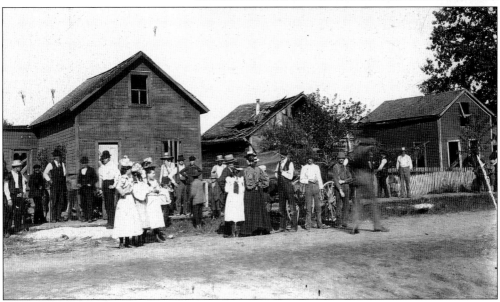

On September 7, 1897, six spectators were killed, several injured, two oil company warehouses destroyed, many houses damaged, and all the plate glass in the South Main Street business district broken when the shooting of the Grant well in the center of Cygnet led to a surface fire. This was followed by an explosion of 52 quarts of nitroglycerine left on a nitro wagon parked nearby. The damage was estimated at $20,000. (Wood County Historical Center and Museum collection.)

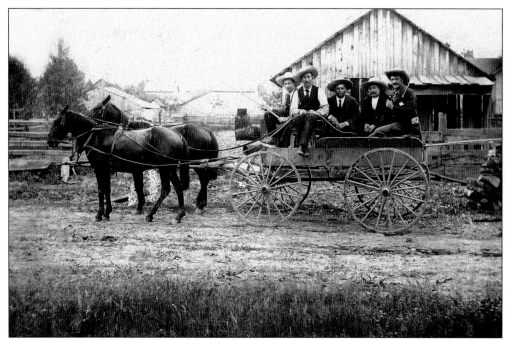

One of the most dangerous jobs in the oil fields was the handling of nitroglycerin. In this photograph, from around the 1880s, five oil workers are using a wagon to haul it to the oil fields of the Jerry City–Cygnet area. (Wood County Historical Center and Museum collection.)

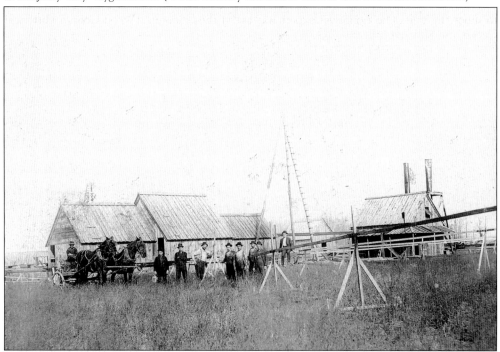

Oil lease pumping activities southeast of Cygnet, around 1903, are shown in this photograph. The man in the white shirt in the background is the field boss for the Ohio Oil Company. (Wood County Historical Center and Museum collection.)

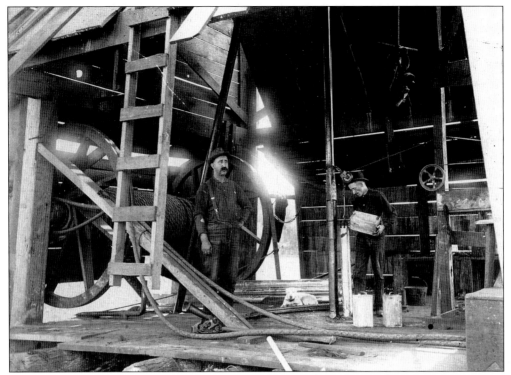

This view of a derrick flow shows a worker filling the torpedo with nitroglycerine in preparation to shoot the well. The explosives expert was called the "shooter." (Wood County Historical Center and Museum collection.)

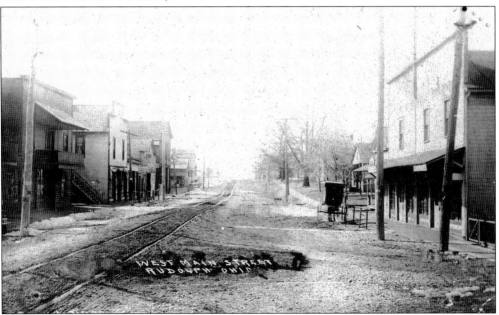

This main street view is of a typical oil boomtown, Rudolph, around 1907. Note the wagon ruts running down West Main Street. The Ohio Oil Company had a field office here. (Wood County Historical Center and Museum collection.)

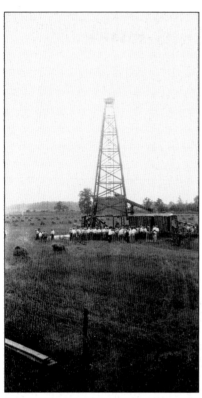

This photograph of an oil derrick near Rudolph, in Wood County, shows quite a crowd of people. It may be a group of investors or just locals out to see the derrick before the drilling gets underway or just before the well is shot. (Wood County Historical Center and Museum collection.)

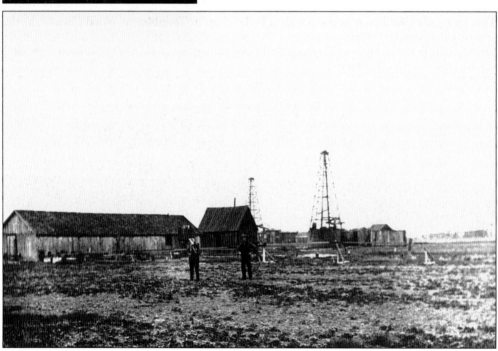

This photograph shows two pumps in front of a wooden shack with a rod running from the pump house to the two wells. This scene is from near Portage, Wood County, around 1900. (Wood County Historical Center and Museum collection.)

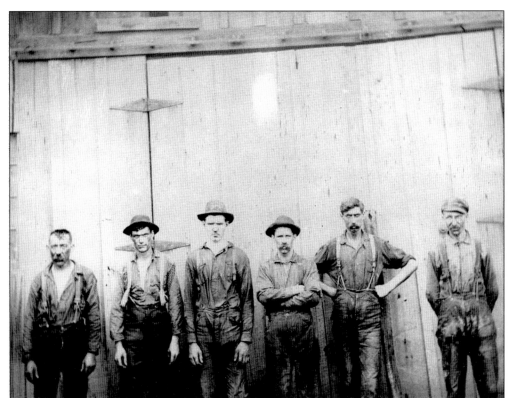

This six-man oil field crew poses outside a boiler shop in Trombley in Wood County. In the picture below of the boiler shop, there is "for sale" written on the boiler in the center of the photograph. Trombley was surveyed in 1885; now it is a ghost town. (Wood County Historical Center and Museum collection.)

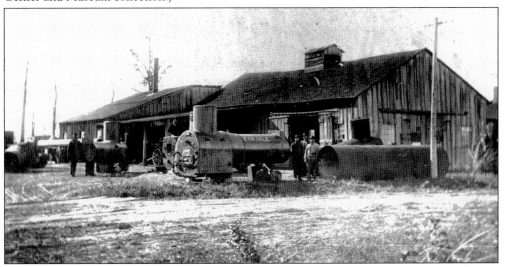

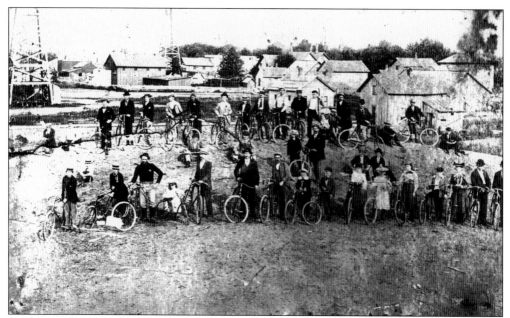

Over three-dozen cyclists of all ages pose in front of derricks scattered about Jerry City, Wood County. (Wood County Historical Center and Museum collection.)

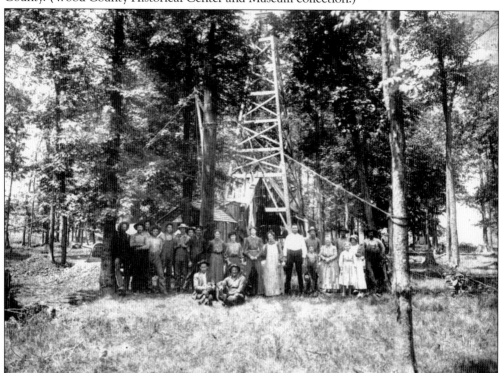

Over 20 men, women, and children pose in front of an oil derrick and boiler house in New Rochester, Wood County, prior to 1909. The first man on the left is Ed Dewyre, the tenth person from the left in the back row is Nellie Zepernick, and the twelfth person in the back row is Mary Dewyre. (Dale Fahle collection.)

Oil Well in Operation near N. Baltimore, O.

Published by H. M. Sommers

Three wells in Portage Township supplied gas to North Baltimore by 1890. Three gas plants and a brick works were enticed to the village by the promise of cheap fuel. Unregulated use led to the rapid depletion of the gas pool, not unlike numerous other area communities. Drillers seeking natural gas in 1886 found oil instead. These two postcards show oil derrick views in the North Baltimore area of southern Wood County. (Mark J. Camp collection.)

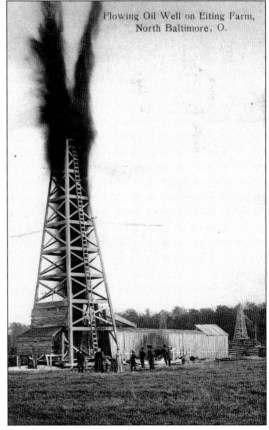

Flowing Oil Well on Eiting Farm, North Baltimore, O.

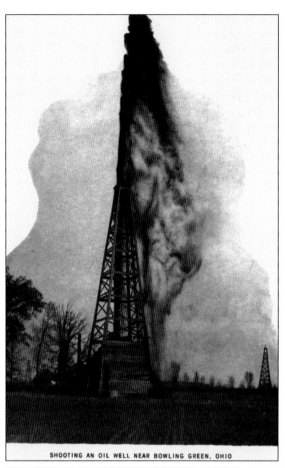

SHOOTING AN OIL WELL NEAR BOWLING GREEN, OHIO

The Bowling Green Natural Gas Company tapped gas in the Trenton Limestone in 1885. The city offered free gas to companies willing to relocate to Bowling Green. In 1887, glass factories were using over three million cubic feet of gas per day, but then the gas pressures began to fall, and by 1890, the reservoir was fairly depleted. Both of these postcards show views of shooting oil wells. The view at left is postmarked 1906, and the message reads, "How is this for high?" The below view is identified as on the McCrory farm (postmarked 1908). (Jeff A. Spencer collection.)

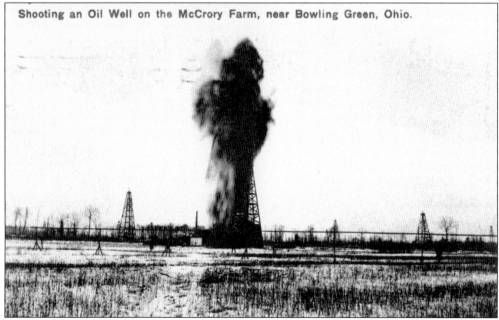

Shooting an Oil Well on the McCrory Farm, near Bowling Green, Ohio.

This view shows two men and their team of horses working on a well near Bowling Green, with another derrick in the background. A good team of horses or mules was invaluable in the early oil fields. (Jeff A. Spencer collection.)

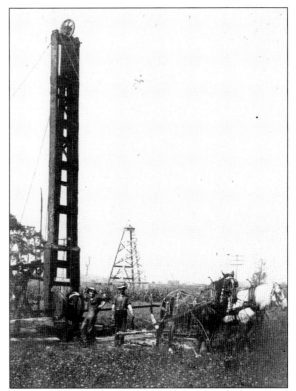

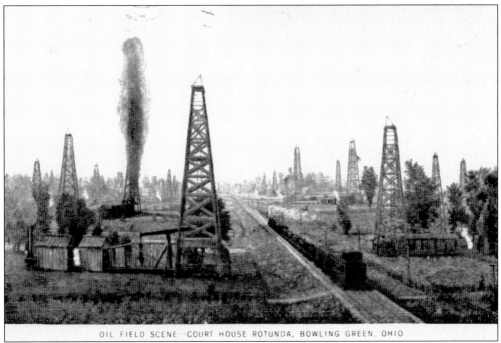

OIL FIELD SCENE—COURT HOUSE ROTUNDA, BOWLING GREEN, OHIO

This postcard shows an oil field scene, complete with over a dozen derricks, a flowing well, and a train traveling through the middle. The postcard's caption places the original painting in the rotunda of the Bowling Green courthouse. (Jeff A. Spencer collection.)

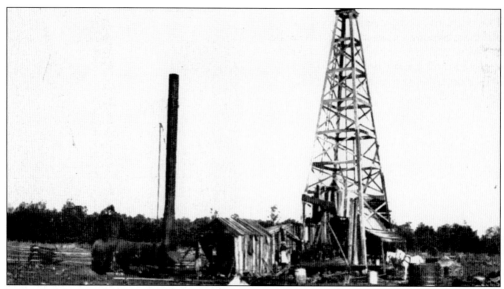

These two postcards show related views of an oil well and boiler near Gibsonburg, Sandusky County. The above view is "getting ready for the shot"; the view below is labeled "shooting the well." (Jeff A. Spencer collection.)

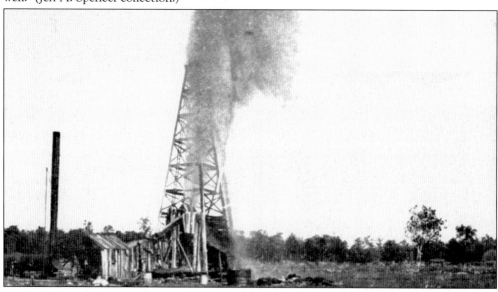

This postcard of "shooting an oil well" is also from Sandusky County, near Woodville. It is a bit surprising that the rig is nestled so close to trees, and that there was not a little more well-site preparation. (Jeff A. Spencer collection.)

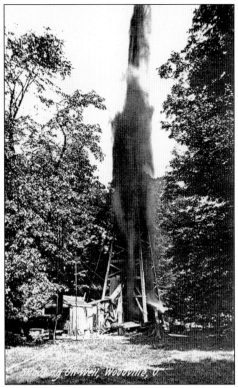

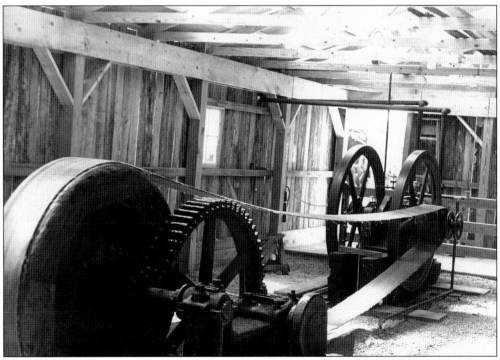

Visitors to the Wood County Historical Center and Museum can examine a replica of an oil well pump house. (Wood County Historical Center and Museum, Bowling Green.)

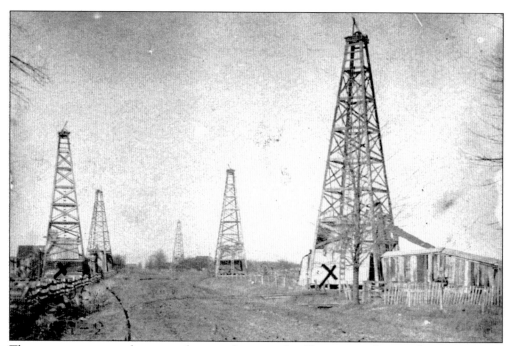

The same person sent these two photograph postcards of Limestone, Ottawa County, in 1908. The note on the back of the above photograph reads, "We run two strings now. The two crosses [x's] on the rigs belong to us." The back of the photograph below reads, "This is our well. We shot it about a week ago". (Jeff A. Spencer collection.)

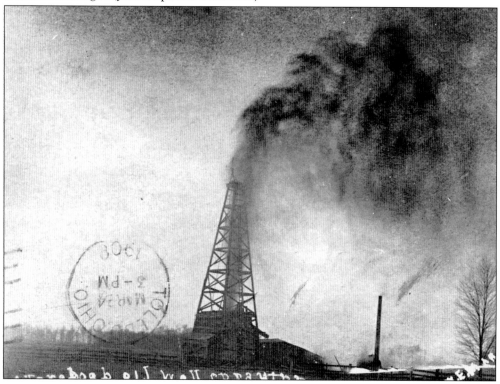

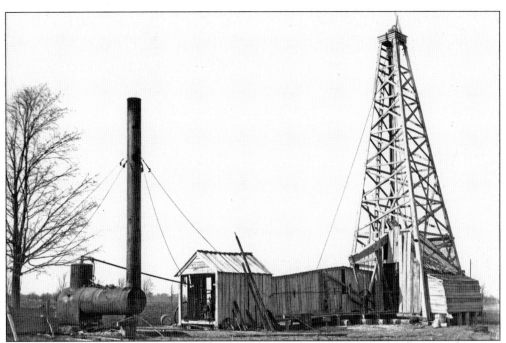

The most notable oil well in Lucas County was drilled on the Miller farm off Millard Avenue near Ironville in 1897. The shooting of this well brought in a gusher; thus, it was given the name Klondyke. According to the drilling crew, the well began at 500 barrels per day, most of which flowed into the nearby creek. By 1902, the Klondyke was averaging 14 barrels of oil daily. Many more wells were drilled in Oregon Township and the surrounding area, but none even closely approached it in production. (Toledo Lucas County Public Library collection.)

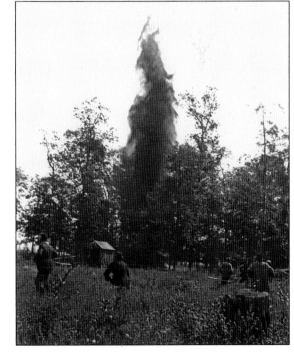

The Trenton horizon was reached on the average about 50 feet below the glacial lake plains of Lucas County. Wells just to the east of Toledo generally were not good producers; many were abandoned in just a few months. A few were gushers like the Wynn Smith well, drilled in 1898 in Oregon Township. (Toledo Lucas County Public Library collection.)

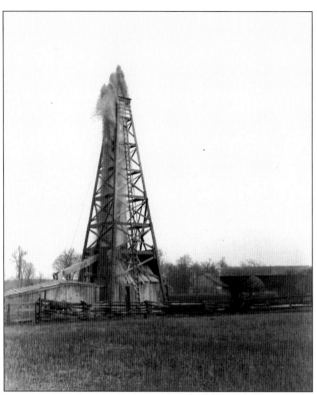

Oil was discovered in Oregon Township in 1885. Representative of the many wells located in this area, just east of Toledo, was the McCaskey well shown here. Although the oil pool dried up rather quickly, Oregon Township became the site of refineries in the 1890s. Standard Oil Company of Ohio opened one in 1919. The Crystal Oil Company refinery was purchased in 1894 and became a Sun Oil property the next year. Paragon Refining Company was taken over by Gulf Oil in 1930. Pure Oil Company opened a small refinery in 1931. (Toledo Lucas County Public Library collection.)

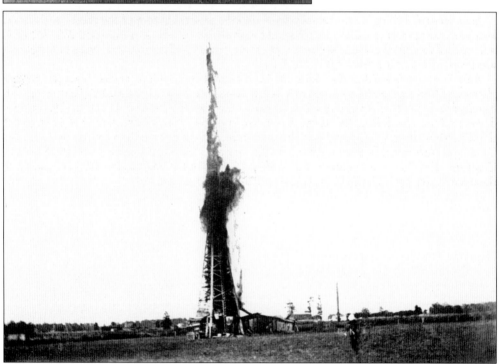

This gushing well is near Ohio City in southern Van Wert County. This county borders the state of Indiana. The giant oil field extends well into Indiana. (Susan Svec collection.)

Three

GRAND LAKE ST. MARYS OIL BOOM

Grand Lake St. Marys (also known as Lake Mercer, Celina Lake, St. Marys Lake, and the Reservoir of the Miami and Erie Canal) is located in Auglaize and Mercer Counties. The lake covers 17,500 acres and is nine miles east to west and three miles north to south. The average water depth is less than seven feet.

The lake was hand dug as a reservoir for the Miami and Erie Canal during the years 1837 to 1845. Over 1,700 workman earned 30¢ a day and a jigger of whiskey (believed to prevent malaria). In 1845, the reservoir was finished ahead of schedule at a cost of $528,222.

As successful drilling in the Lima-Indiana oil field progressed toward the shores of the lake, local entrepreneurs recognized the potential for oil under the lake. An estimated 200–300 wells were drilled in the lake, with production beginning in 1891. The objective Trenton Limestone was encountered at depths of 1,100–1,200 feet.

Wells were drilled along the shore of the lake and from pile-supported wooden offshore platforms. Wind, ice, and occasional fires took their toll on the wooden derricks. Natural gas was flared from the wells, illuminating the roadway on the eastern lakeshore. Local small companies dominated the lake drilling. St. Marys–based Armstrong and Scott was active on the east end of the lake, Manhattan Oil Company on the south side, and the Bryson Company on the west side. Other operators in the lake were Reservoir Oil, German American, Bankers', and the Riley Oil Company. The Riley Oil Company drilled over 100 wells in the lake, and by 1908, only seven of them remained. By 1910, the Grand Lake St. Marys oil boom was over.

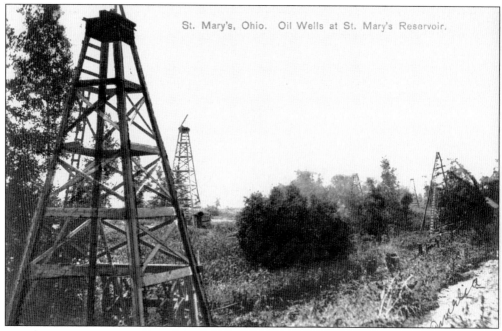

St. Mary's, Ohio. Oil Wells at St. Mary's Reservoir.

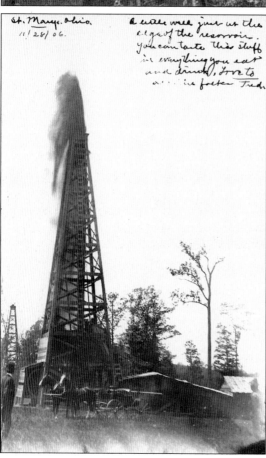

These two views are of derricks near the shoreline of Grand Lake St. Marys. The above view is a postcard, postmarked November 13, 1908. The photograph at left, dated November 28, 1906, has the inscription, "little well just at the edge of the reservoir. You can taste this stuff in everything you eat and drink." (Above, Jeff A. Spencer collection; left, George Neargarder collection.)

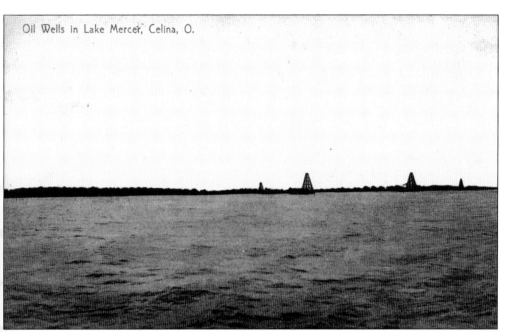

Oil Wells in Lake Mercer, Celina, O.

These two postcard views refer to the lake as Lake Mercer, one of many names that the lake has gone by. The above view shows four derricks out in the lake and is postmarked 1913. The moonlight view below is postmarked April 12, 1909. The message on the back reads, "you can see a couple of oil derricks!" (Jeff A. Spencer collection.)

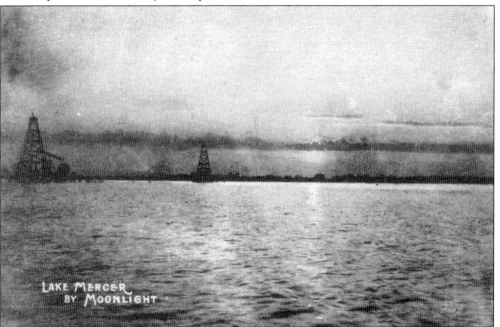

LAKE MERCER
BY MOONLIGHT

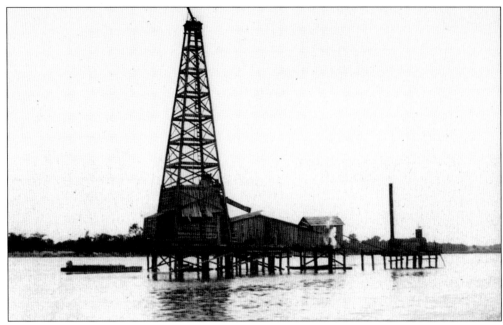

Pile-supported platforms were necessary to drill the wells in the shallow lake. The upper view shows a smaller platform to the right of the derrick with the boiler. This separate platform was probably to reduce the chances of losing the entire operation if there was a boiler fire. (George Neargarder collection.)

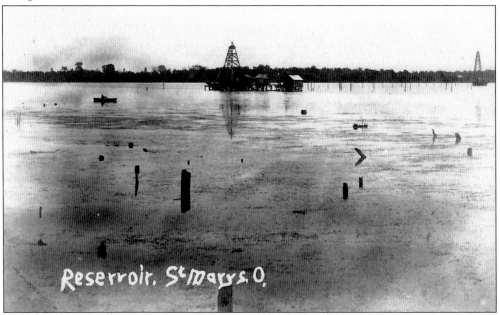

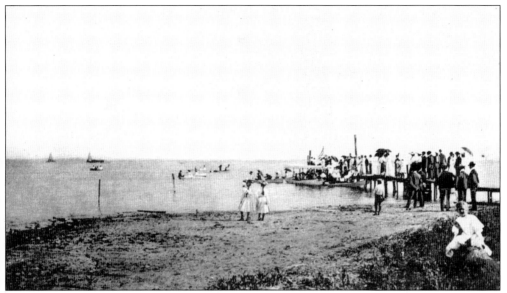

The boat landing at the Chautauqua Grounds near Celina shows a well-dressed crowd, including women with parasols, ready for a boat ride. Two oil derricks are visible in the background, as swimmers, boaters, and people play on the shore of the lake. (Jeff A. Spencer collection.)

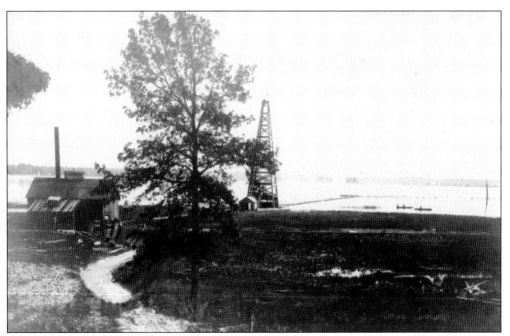

The local oil operators may not have realized at the time what a historic bit of oil field history was being made in Grand Lake St. Marys. Many oil field historians assume that the first oil drilling over water occurred some years later in Louisiana's Caddo Lake. (George Neargarder collection.)

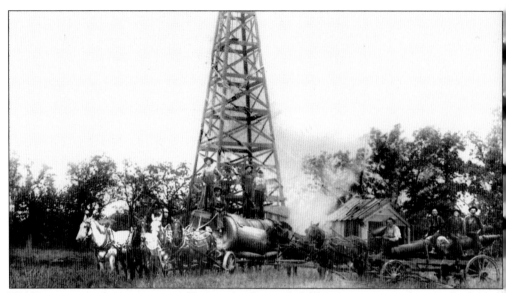

Workers pose with two teams of horses hauling oil field equipment in this nicely framed photograph with the derrick in the middle background. Written on the back are the words, "First well in Noble Twp. [Township] J. Shipman." This may refer to John Shipman. The first oil and gas lease executed in Auglaize County was on July 19, 1886, and included land owned by John and Louise Shipman in Noble Township. The terms included a one-eighth royalty to the landowners on the oil, and $50 a year for each gas well bought in on the lease. Wells were successfully completed on this lease. (George Neargarder collection.)

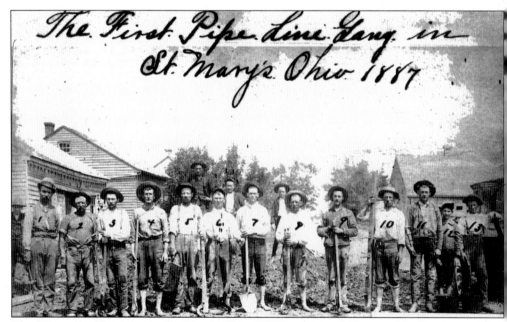

The "First pipe line gang in St. Mary's Ohio 1887" consists of 11 rugged looking men, some barefoot, with their shovels and tools. The two boys on the far right of the picture pose with buckets, rather than shovels. Their duties may have included providing water to the pipeline diggers. (George Neargarder collection.)

Four

THE SCIO OIL BOOM

One of the most dramatic, though short-lived, Ohio oil booms occurred in eastern Ohio in and around the Harrison County village of Scio. With the discovery of oil in the vicinity of the nearby town of Jewett in 1895, the Scio Oil and Gas Company was established and began drilling in the Scio area. After several attempts, they discovered a prolific oil pool in 1898. The two-year boom resulted in over 1,000 wells drilled in the area, approximately a quarter of the wells within the village itself.

The population of Scio grew from approximately 900 preboom, to approximately 12,000 at the height of the oil boom. Boarding room rates quickly soared from 60¢ per week to $5–10 per week. The local Scio College saw its attendance decrease from 300 to 25 students, as they rushed to work in the oil fields, and 11 saloons sprang up. The Pennsylvania Railroad put an extra train in service from Pittsburgh, known as the "greaser," to accommodate the rush to the boomtown. The intersection of Main and Elm Streets became known as "mud sock," as the many horse-drawn oil supply wagons would get stuck knee-deep in mud after a good rain.

The actor Clark Gable was born in the Harrison County town of Cadiz in 1901 and his father, William, worked in the oil fields of the Scio oil boom. By 1901, the boom had largely subsided and the village population dropped to less than 1,300.

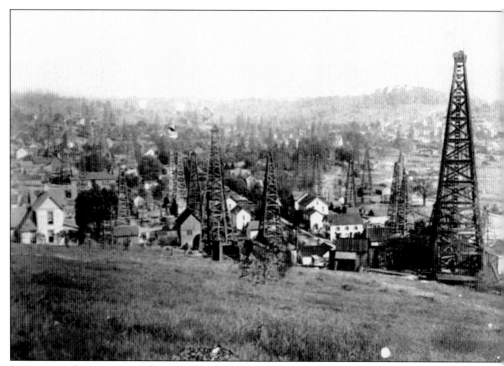

It is easy to lose count of the dozens of oil derricks in this town view of Scio, probably at the height of the oil boom. (Dee Ann Horstman, Scio Museum collection.)

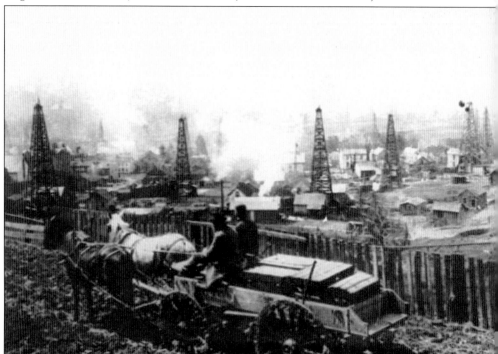

This view of a team of horses with oil derricks in the background looks south towards Scio from Carrollton Street. (Dee Ann Horstman, Scio Museum collection.)

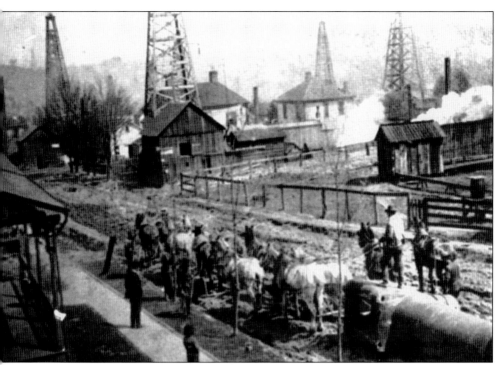

A horse (or mule) team and supply wagon transport what is possibly a boiler along Grandview Street, towards College Street, on the south side of Scio. (Dee Ann Horstman, Scio Museum collection.)

COLLEGE VIEW, SCIO, OHIO.

Scio College originated as the Rural Seminary in Harlem Springs in 1857. It moved to New Market, now Scio, in 1867 and was known as New Market College and later, One Study University. It was renamed Scio College in 1878 and merged with Mount Union College in Alliance in 1911. The local oil boom drew many students away from the college to work in the oil field. (Carl Heinrich collection.)

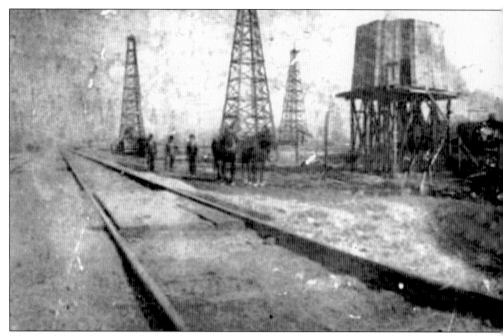

These oil derricks are in the background of the Pennsylvania Railroad yard in Scio, located near the center of town and running east to west. The tracks are gone now and part of the line has been converted to a bike trail. (Dee Ann Horstman, Scio Museum collection.)

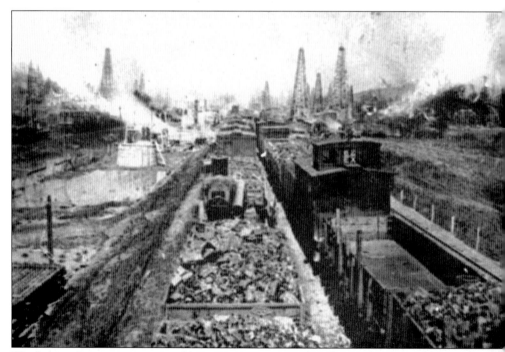

The "greaser" train was so named because its main travelers during the Scio oil boom were oil field workers. In the background of the photograph, the forest of derricks seems to go on and on. (Dee Ann Horstman, Scio Museum collection.)

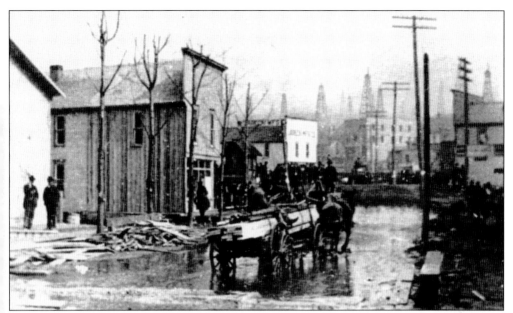

This 1898 view of downtown Scio was taken looking east. The load of lumber is probably heading toward some type of construction associated with the oil boom. As with many oil booms, it seems as though choice drilling locations end up on town lots. (Courtesy of Deb LaFromboise.)

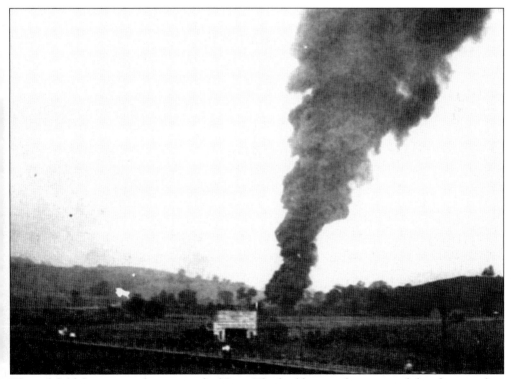

This oil field fire is near the west end of Scio. The building in the center of the photograph is the Buckeye Pipeline Company building. (Dee Ann Horstman, Scio Museum collection.)

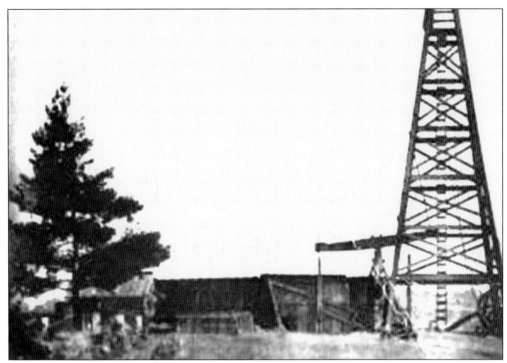

This postcard is titled "In the oil fields of Scio" and was postmarked on August 19, 1906, in Cadiz, also in Harrison County. (Dee Ann Horstman, Scio Museum collection.)

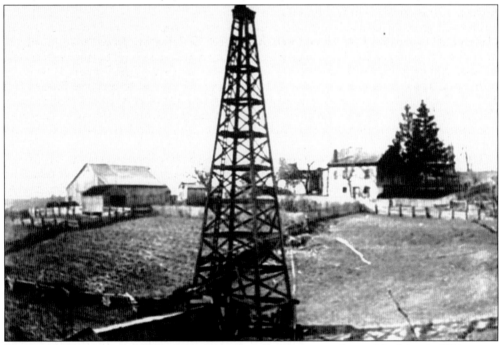

The Scio Museum has a drill bit from this well and a mock-up scale model of the rig. This scene is high on a hill on Cemetery Road. This photograph is titled, "Fowler home during oil boom." (Dee Ann Horstman, Scio Museum collection.)

Five

THE BREMEN AND NEW STRAITSVILLE OIL BOOMS

Gas was discovered in south-central Ohio throughout the late 1880s and 1890s. The Corning oil field was discovered in 1891 when the Toledo and Ohio Central Railroad encountered oil while drilling for water. During the next 10 years, over 900 wells were drilled in the field in Athens, Perry, and Morgan Counties. The field produced over 2.7 million barrels of oil from 1893 to 1902. Much of this oil was transported to Elba via the Buckeye Pipeline Company.

Gas was first discovered in Fairfield County in 1896, when the Rush Creek Oil and Gas Company encountered gas in its J. Stuart well. The company supplied gas to the towns of Bremen, East Rushville, and West Rushville for a few years.

The well generally credited as the discovery well for the Bremen oil field was the Bremen Gas and Oil Company's J. W. Huston well. In October 1907, the well flowed at an initial rate of 140 barrels of oil per day. The company's confirmation well, the L. and S. Householder well, completed in early 1908 with an even higher initial flow rate, set off the Bremen oil boom. A rush for oil leases drove up the price to $12.50 per acre. By the end of 1909, the Bremen Gas and Oil Company had completed 70 of 90 wells and many other oil companies joined the rush. Within the village, wells were drilled on lots so close together that a person could jump from one derrick floor to another. Approximately 2.5 million barrels of oil were produced through September 1910.

The village of Bremen celebrates its oil industry heritage every September at the Oil Derrick Days. The 2007 event marked the centennial of the discovery of the Bremen oil field. The Bremen oil boom lasted until the early 1920s and included the drilling and completion of wells near the surrounding towns of Rushville, Pleasantville, Junction City, Crooksville, Shawnee, and New Straitsville.

Established in 1870 as a coal town, New Straitsville is also the birthplace of the United Mine Workers (UMW). The Purvis-Martin Oil and Gas Company completed the discovery well for the New Straitsville oil field on July 4, 1909. As with Bremen, oil derricks soon crowded the town lots, with over 100 wells drilled within the village limits. Later in 1909, the oil field's limits extended into Hocking County. The New Straitsville History Center includes exhibits on the local oil history.

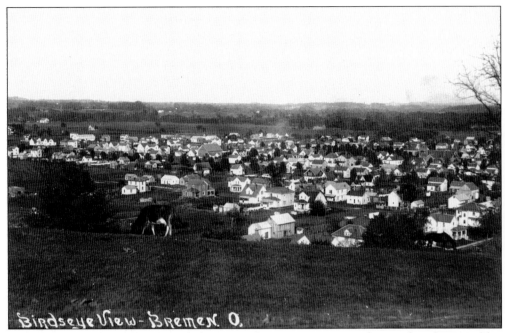

Birdseye View - Bremen, O.

The village of Bremen was founded in 1834 by George Berry and named in honor of his father-in-law's hometown in Germany. The above bird's-eye view of the village, dated November 10, 1912, captures a pastoral setting, complete with cow. The view below shows a scene with over 20 oil derricks in and about the village. (Above, Bob Crego collection; below, Mark J. Camp collection.)

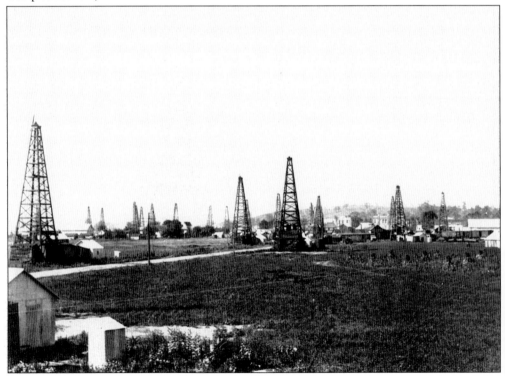

The Bremen Gas and Oil Company's Householder well was the confirmation well for the Bremen oil field. The well was completed in February 1908. The photograph at right, dated May 9, 1908, states a flow rate of 400 barrels of oil per day; the below photograph states 200 barrels of oil per day. The well was drilled to a depth of 2,619 feet and completed in the Clinton Sand from 2,585 to 2,619 feet. More so than the discovery well, this well set off the Bremen oil boom. (Right, Bob Crego collection; below, Carl Heinrich collection.)

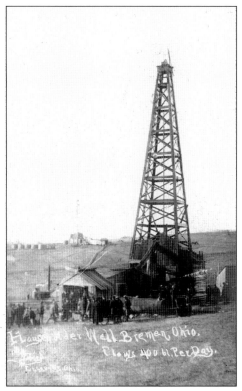

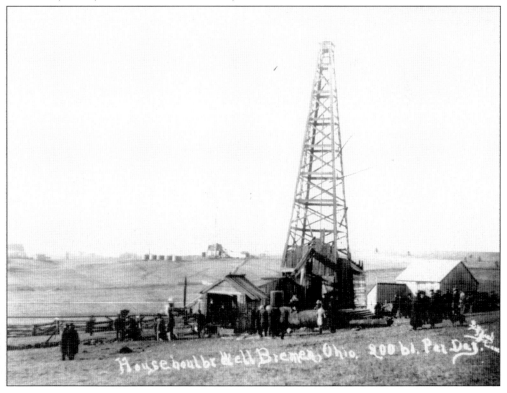

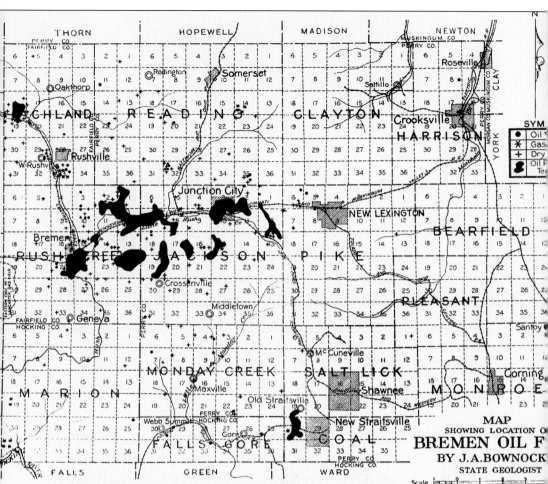

A 1910 map of the Bremen area shows the oil field (shaded) extending from Bremen eastward towards Junction City. Other key towns that enjoyed successful drilling results were (clockwise from Bremen) Rushville, Somerset, Crooksville, Corning, Shawnee, and New Straitsville. (Ohio Department of Natural Resources, Division of Geological Survey.)

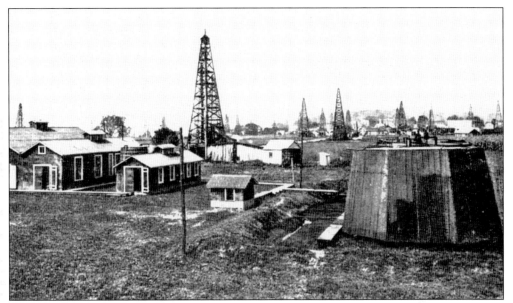

During the first year of oil production, the oil was pumped into railroad tank cars. In 1908, the Buckeye Pipeline Company, a subsidiary of Standard Oil Company of Ohio, built a pipeline and pumping station near town. As more oil was produced, the company had to increase the pipeline size from three inches to four inches to six inches. During the field's first two years of production, oil sold for $1.78 per barrel. (Jeff A. Spencer collection.)

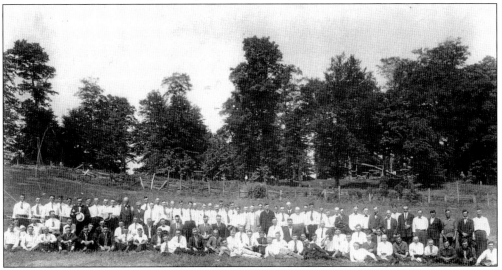

The Carter Oil Company, an affiliate of Standard Oil Company of Ohio, drilled its first well in the Bremen area in January 1908; it was a dry hole. The Carter Oil Company bought out Bremen Gas and Oil Company in 1911. Early wells were drilled with steam engines. In 1918, the Carter Oil Company was the first company in the area to use gas engines. The company grew to one of the largest companies in southeast Ohio with 467 oil wells and 30 gas wells in 13 counties. In 1926, the local holdings of the Carter Oil Company were merged with the Hope Construction and Refining Company, a subsidiary of the Hope Natural Gas Company of West Virginia. This photograph shows the Carter Oil Company's first annual picnic in 1919. (Bremen Area Historical Society collection.)

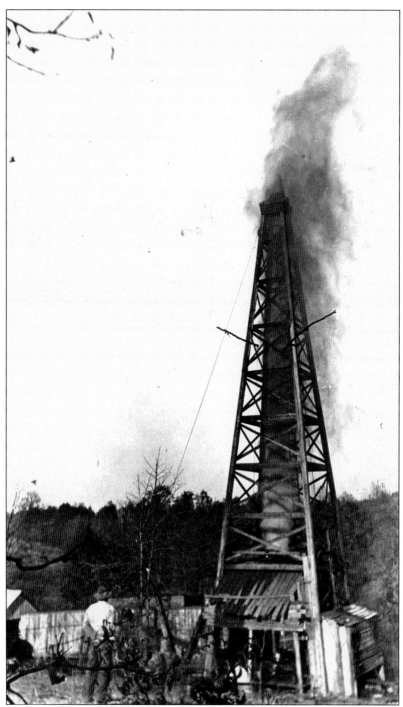

A man watches a Bremen-area well blow. The two sticks coming out from the derrick were called balance poles. An average 1910 wooden derrick was approximately 80 feet high and cost approximately $725. Metal derricks were less common and cost approximately $900. An average well, drilled and completed to a depth of 2,450 feet, cost approximately $6,830, and the operation would take 30 days. (Bremen Area Historical Society collection.)

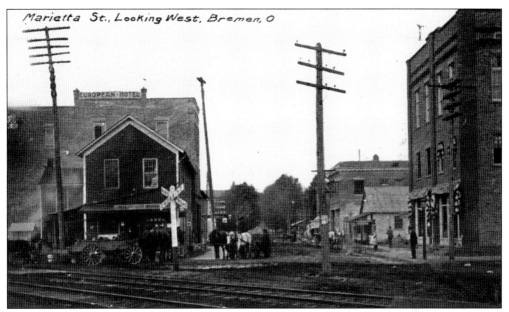

Bremen's business district saw rapid growth during the oil boom. The above photograph shows Marietta Street looking west. The photograph below shows Shelhemer's Block, dated August 1911 with several wooden oil derricks within the village. (Above, Jeff A. Spencer collection; below, Bob Crego collection.)

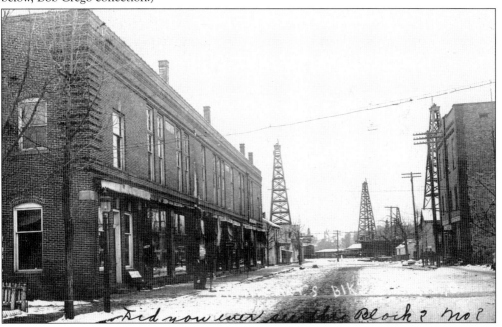

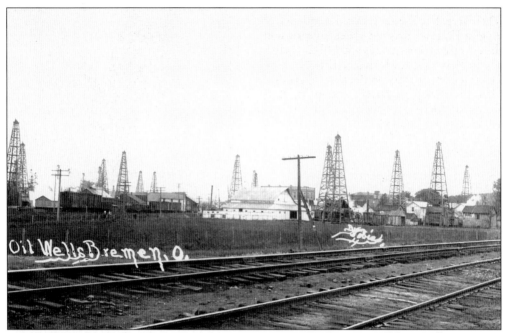

These two views show numerous wooden derricks along the Cincinnati and Muskingum Valley Railroad tracks in Bremen. The photograph above is dated August 13, 1910, and the photograph below is dated August 12, 1912. (Above, Bob Crego collection; below, Jeff A. Spencer collection.)

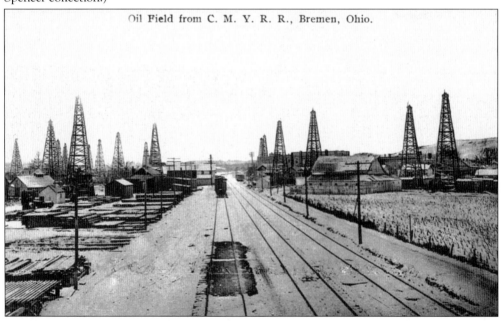

Oil Field from C. M. Y. R. R., Bremen, Ohio.

The Purvis No. 3 well, in this image dated August 12, 1908, may have been an early well drilled by the Bremen Gas and Oil Company on the Purvis farm, which adjoined the Householder property on the east. This same view was labeled "shooting an oil well in the Rushville-Bremen oil field" on another postcard. (Bob Crego collection.)

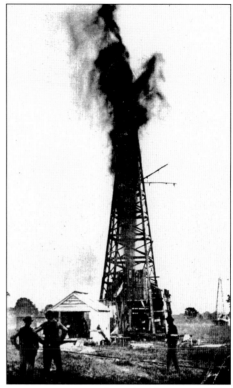

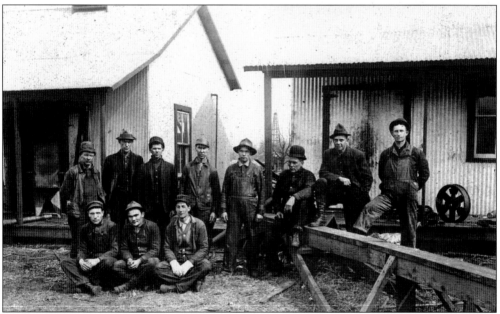

In this image, 11 oil field workers pose in front of a boiler house (left). A derrick chair sits on the porch. The wooden structure (that the third man from the right is sitting on) is the steam box. The box contains the steam pipe packed in sawdust for insulation. An oil derrick can be seen in the background between the two buildings. The only man identified in the picture is Joe Moose, the fifth man from the left in the back row. (Bremen Area Historical Society collection.)

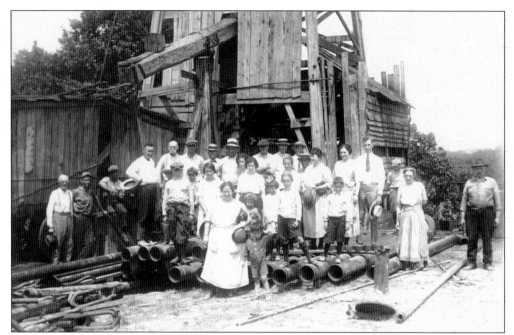

In this image, 29 people of all ages pose in front of a wooden oil derrick in the Bremen area. All but four of the people appear to be in their Sunday clothes. It was common to have large groups come out to an oil derrick on a Sunday after church for a group photograph. The Martin's Studio of Logan produced this photograph. (Bremen Area Historical Society collection.)

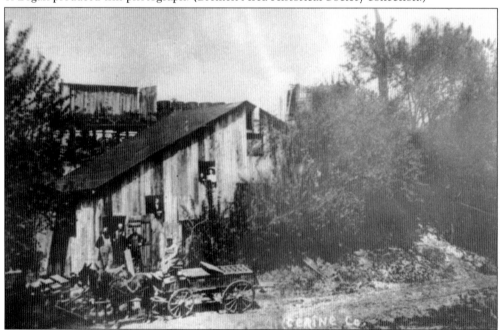

This factory was located two miles northwest of Bremen and provided nitroglycerine for the oil industry. On May 18, 1923, the factory was destroyed by an explosion, cause unknown. There were no human casualties, as the workers had left for dinner just 15 minutes earlier. Three cows were killed by the blast. (Bremen Area Historical Society collection.)

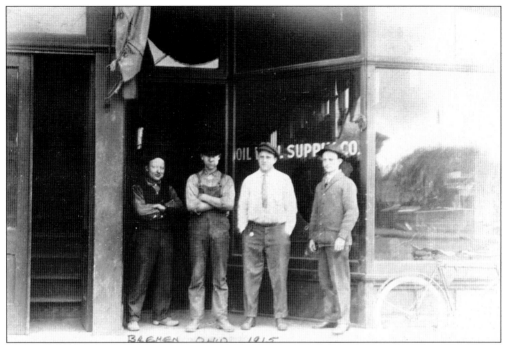

Four men (unidentified) pose in front of the Bremen Oil Well Supply Company. Every oil boomtown had at least one oil supply store. The photograph is dated 1915. (Carl Heinrich collection.)

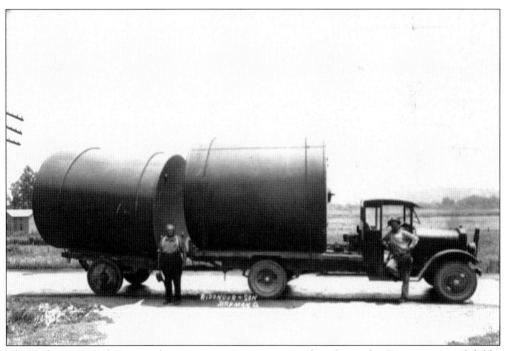

The Ridnenour and Son truck is preparing to transport oil tanks in the Bremen-area oil fields. Trucks replaced the teams of horses and mules used during the boom years. (Bremen Area Historical Society collection.)

THE
Bremen Oil & Gas Stock Exchange
ESTABLISHED FEBRUARY, 1908.
WRIGHT & TURNER, Proprietors.

Bremen, Ohio, _____ *1909*

This stock is quoted to you 'till _____ 1909, 8 o'clock, P. M., unless otherwise specified, and is snbject to prior sales.

COMPANY	No. Shares	BID	Asked	COMPANY	No Shares	BID	Asked
Acre				Mount Hope			
Amber				New Ideal			
Avelon				Perl			
Bremen				Purvis-Turner			
Bunker Hill				Purvis-Martin			
Capital				Radcliff			
Clayton				Reading			
Crossenville				Rushville			
Crescent				Rushcreek			
Diamond				Saffel			
Elder				West Rushville			
Ebeneezer				West Point			
Eureka				Twin Bridges			
Fairfield							
Flagdale							
Franklin							
Holliday							
Junction City							
Kenyon							
Kochensparger							
Maxville							
McLuney							
Monarch							

In case you are in the market for any stock not here listed, we would be pleased to correspond with you in regard to same.

Yours very respectfully,

Both Phones. **WRIGHT & TURNER.**

This unused stock quote sheet lists 36 oil companies on the local stock exchange. The Bremen Oil and Gas Stock Exchange was established in February 1908. (Bremen Area Historical Society collection.)

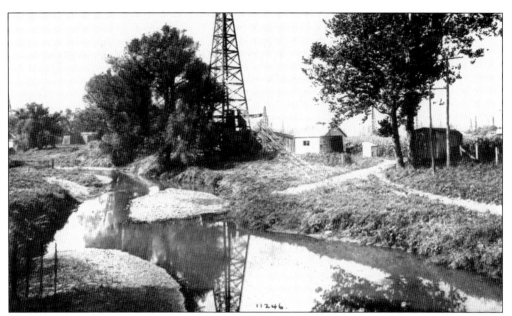

This photograph postcard is titled "Mirror effect in Bremen oil field near Lancaster, Ohio" and was postmarked on November 20, 1911. (Jeff A. Spencer collection.)

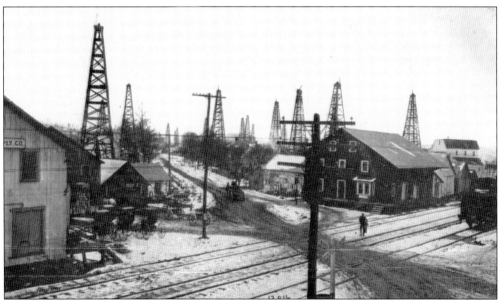

A winter scene on South Broad Street near the Hocking Valley Railroad track shows several horse and buggies with over 15 wooden oil derricks in the background. This photograph is dated August 12, 1914. (Jeff A. Spencer collection.)

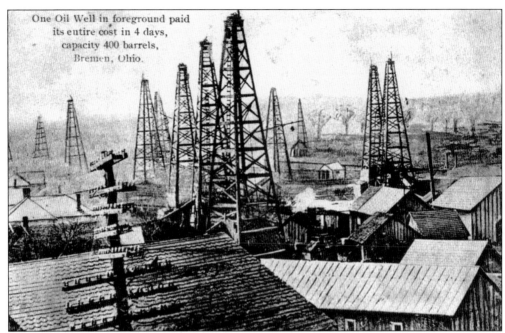

One Oil Well in foreground paid
its entire cost in 4 days,
capacity 400 barrels,
Bremen, Ohio.

Oil derricks crowd among Bremen buildings. The above view is labeled, "one well in foreground paid its entire cost in 4 days, capacity 400 barrels." In 1909, Great Expectation Oil Company completed a well with a capacity of 400–500 barrels of oil per day on a Bremen town lot. This set off a period of rapid town-lot drilling (and over drilling) often resulting in two wells on one lot. By July 1, 1910, 36 wells had been drilled on town lots; 30 of those were completed as oil wells. (Jeff A. Spencer collection.)

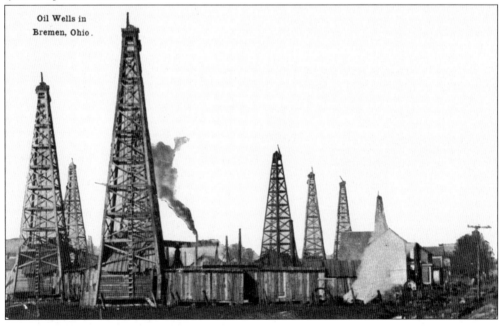

Oil Wells in
Bremen, Ohio.

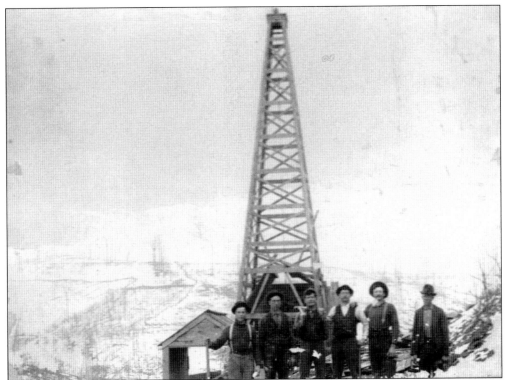

Six men pose in front of a Bremen-area oil derrick. The last man on the right was identified as F. C. Sharpnack. (Bremen Area Historical Society collection.)

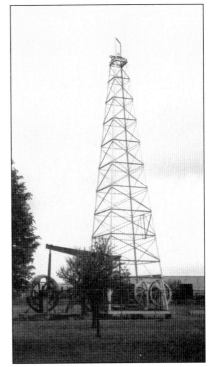

In 1984, this 1920s vintage oil derrick was disassembled and moved from a farm near Roseville in Perry County to Bremen's Howell Park, as seen here in 2007. The year 1984 marked the village of Bremen's sesquicentennial (1834–1984). (Photograph by Jeff A. Spencer.)

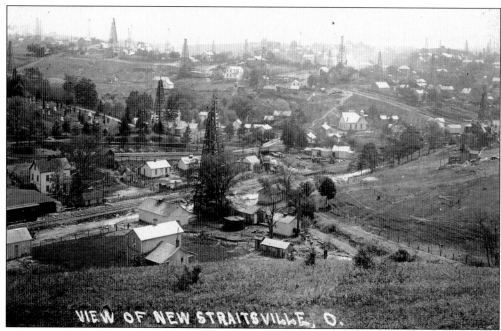

VIEW OF NEW STRAITSVILLE, O.

Two views of New Straitsville show numerous oil derricks scattered amongst the hills and near homes. In 1880, the town's population was over 4,000 due to an active coal-mining boom in south-central Ohio. With the decline of coal mining, the town's 1900 population fell to 2,302. Though no numbers are available for the short period of New Straitsville's 1909 oil boom, the population certainly increased dramatically. Today the population is less than 800. (Above, Jeff A. Spencer collection; below, New Straitsville History Center collection.)

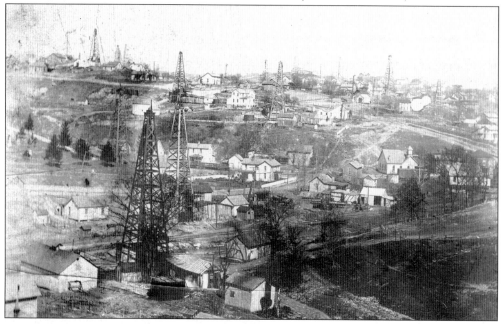

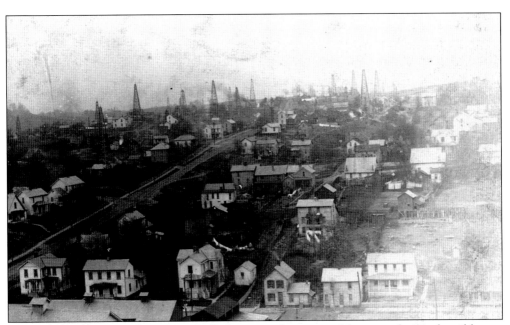

This photograph, taken from Essex Hill, shows another view of the town during the oil boom. (New Straitsville History Center collection.)

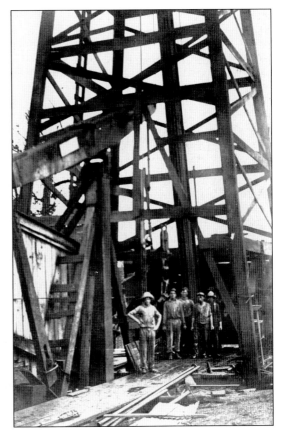

This five-man rig crew poses on a New Straitsville derrick. The discovery of possible oil pools led to the employment of many. Rig builders were needed to build the derricks. Drillers and tool dressers followed. The tool dressers kept the bits sharp, fired the boilers, and were general handymen. They worked 12-hour shifts, taking two–three weeks to complete the drilling. Teamsters were needed to haul the supplies. Often local farmers performed these tasks. Shooters were needed to handle the nitroglycerin. Pumpers operated the machinery to pump oil from the well to storage tanks. Boardinghouses were erected in many of the towns to house the sudden influx of workers, most of whom were unmarried. Saloons and oil supply houses were common. (New Straitsville History Center collection.)

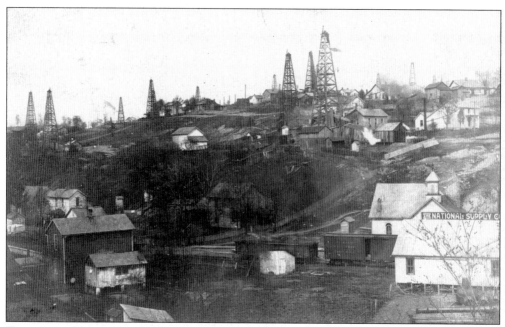

Two views of lower Cow Hill were photographed from the downtown area. The above view shows the National Supply Company Building in the right foreground. The same building is in the left foreground of the view below. (New Straitsville History Center collection.)

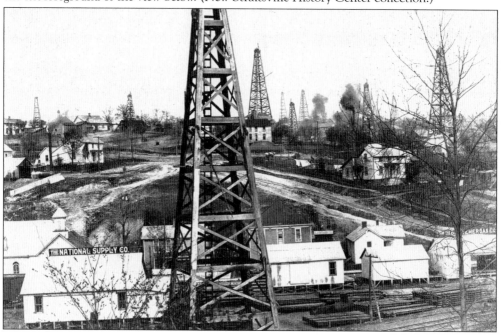

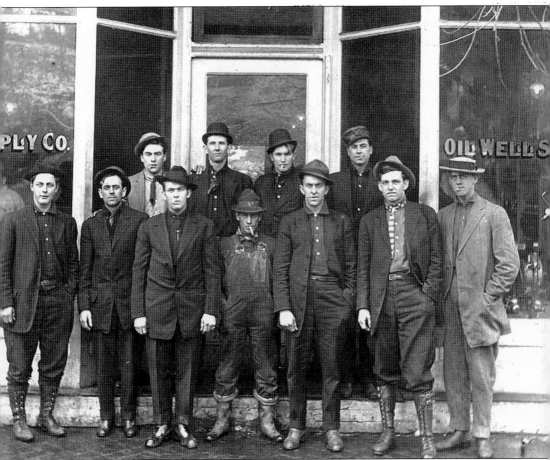

In this image, 11 men, perhaps oil field workers, are posed in front of the National Supply Company office in New Straitsville. Another man looks out the window on the left. The National Supply Company was established in 1893 and had stores in most oil field towns providing oil field supplies. (New Straitsville History Center collection.)

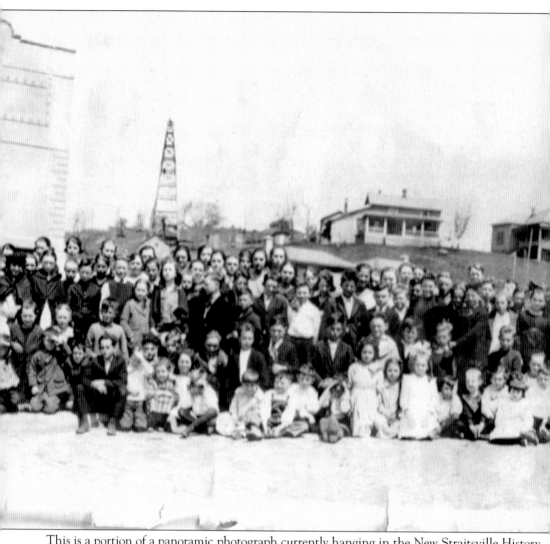

This is a portion of a panoramic photograph currently hanging in the New Straitsville History Center. The 1917 photograph shows the New Straitsville school, a group of students, and an oil derrick in the background. (New Straitsville History Center collection.)

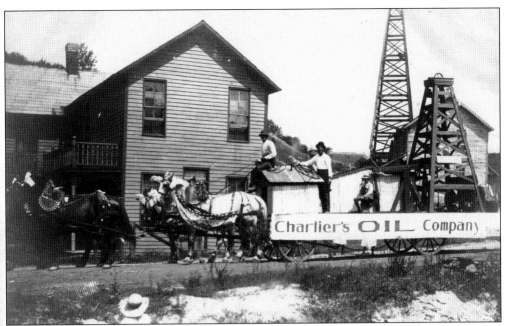

The 1913 Fourth of July parade shows floats along Main Street with oil derricks in the background. The above photograph shows the Chartier's Oil Company float. Other early oil producers in the New Straitsville area include the Columbus and Hocking Coal and Iron Company, the Ebenezer Oil and Gas Company, and the Kachelmacher Oil Company. N. L. C. Kachelmacher also operated a brickyard in town. (New Straitsville History Center collection.)

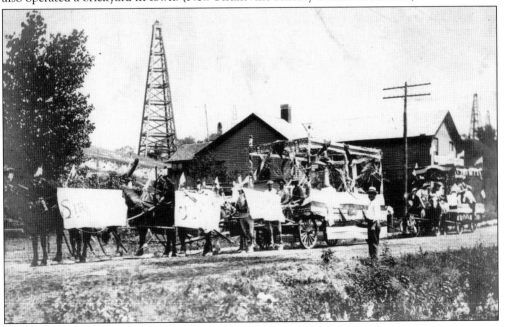

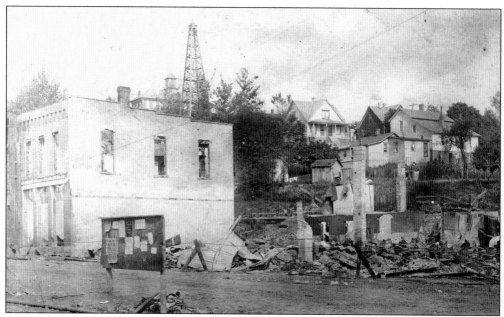

In 1913, a fire ravaged the downtown area of New Straitsville. The above view is of the Airdome Theatre at Main and Clark Streets, where the fire started. The view below shows another town view of the fire damage. Both photographs show oil derricks in the background. (New Straitsville History Center collection.)

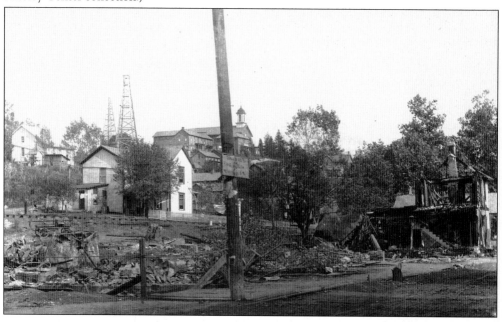

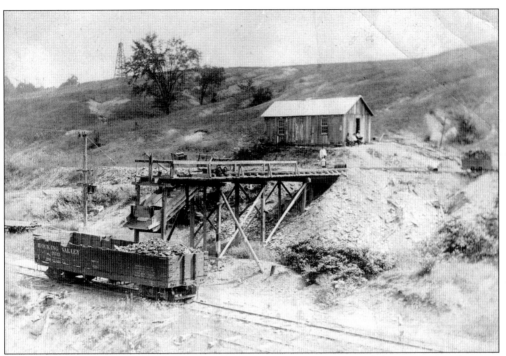

Coal mining was the first major industry in New Straitsville, founded in 1870 by the New Straitsville Mining Company. The major period of coal mining ended in the mid-1880s. This photograph shows a Hocking Valley Railroad coal car with a derrick in the background. (New Straitsville History Center collection.)

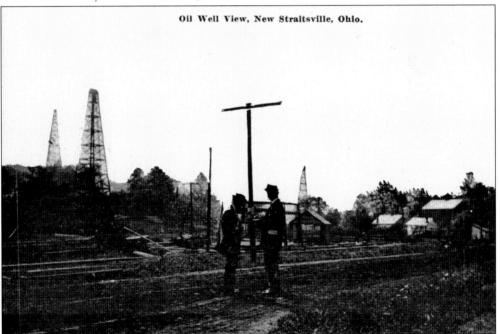

Oil Well View, New Straitsville, Ohio.

This photograph shows two men standing near the railroad tracks in New Straitsville with oil derricks in the background. (Jeff A. Spencer collection.)

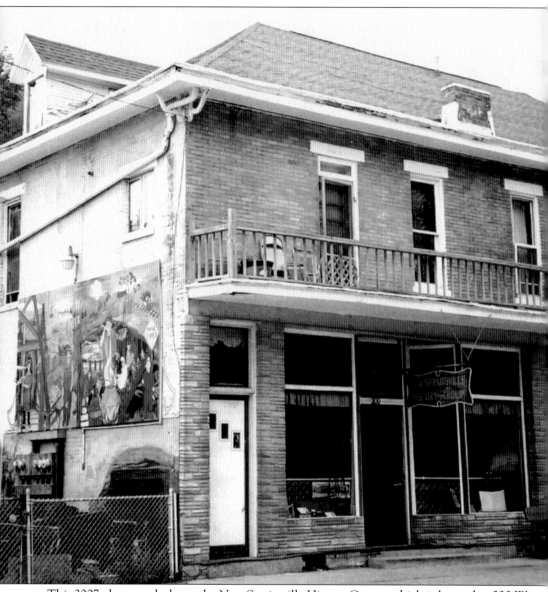

This 2007 photograph shows the New Straitsville History Center, which is located at 200 West Main Street. The museum houses exhibits on the area's history, including an impressive recreation of an early coal mine in the museum's basement. The New Straitsville History Center has a second building in town near Robinson's Cave, the claimed birthplace of UMW. (Photograph by Jeff A. Spencer.)

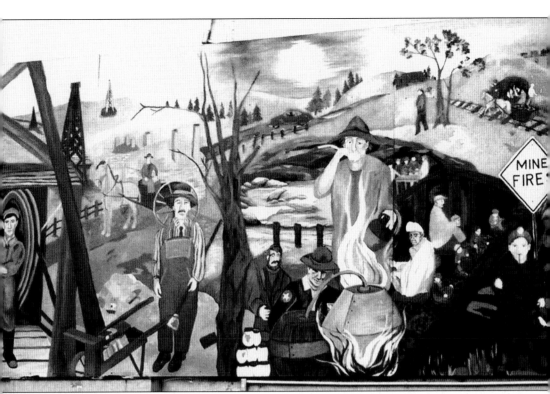

Seen in this 2007 photograph, the mural on the side of the New Straitsville History Center was dedicated on Memorial Day weekend, 1999, during the annual Moonshine Festival. The mural depicts the four major local industries: coal, oil, clay, and moonshine. The muralist was Sandra Russell, assisted by Kim Blosser and a dozen local youth. (Photograph by Jeff A. Spencer.)

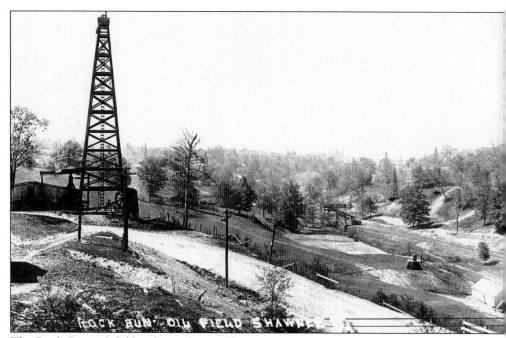

The Rock Run oil field is located near Shawnee in Perry County, approximately two miles northeast of New Straitsville. Several derricks can be seen off among the trees. The message on the reverse of this photograph postcard reads, "This is a picture of Pa's new oil well at Shawnee." (Jeff A. Spencer collection.)

The town of Crooksville, in Perry County, was known for the Crooksville China Company (1902–1959). The Crooksville oil pool was discovered in 1909. (Jeff A. Spencer collection.)

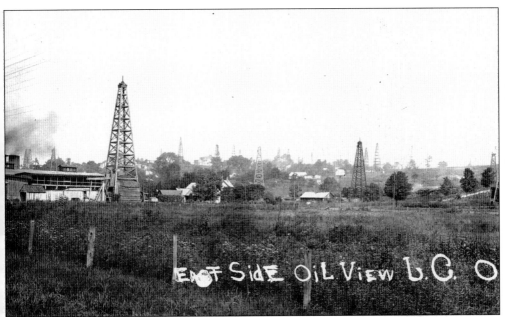

EAST SiDE OiL View J. C. O

Junction City, in Perry County, was established in 1872 with the merger of the towns of Trio City and Damascus. The Alberta Oil and Gas Company discovered the Junction City oil pool in 1909, which produced from the Clinton Sand. The above view of the town is a 1910-postmarked photograph postcard with a message on the reverse that reads, "Some derricks here, don't you think?" The photograph at right is a close-up view of two Junction City derricks. (Above, Jeff A. Spencer collection; right, Mark J. Camp collection.)

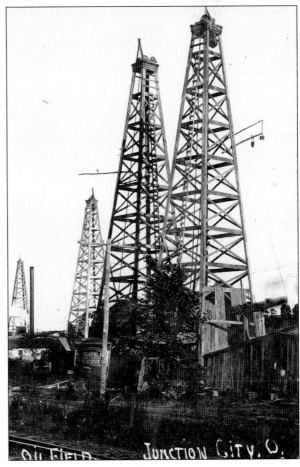

OIL FIELD. JUNCTION CiTY. O.

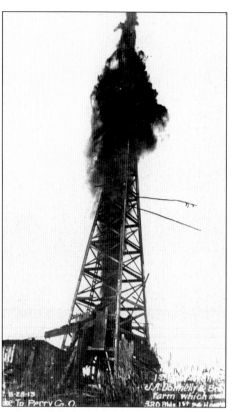

This image shows a Pike County well and is labeled, "Pike Tp [Township] Perry Co. O. 8-28-13. First flow well #2 J.A. Donnelly & Bro. Farm, which made 320 Bbls [barrels] 1st 24 hours." (Jeff A. Spencer collection.)

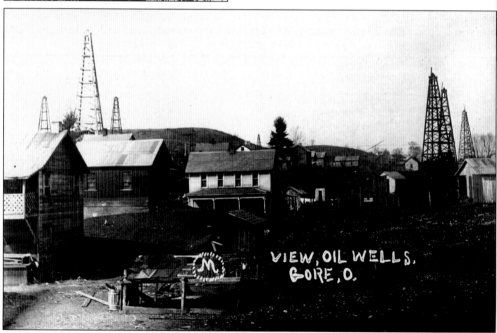

Gore is located in Hocking County, approximately four miles west of New Straitsville. The Gore oil pool was discovered in 1911 and produced from the Clinton Sand. Derricks crowd a few homes in this 1913-postmarked photograph postcard. (Jeff A. Spencer collection.)

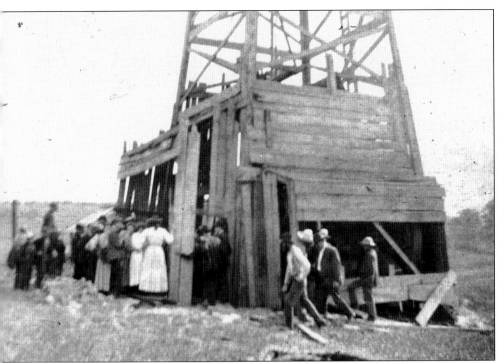

In northern Perry County, the Somerset field was discovered in 1925. Both the Berea Sand (at approximately 1,800 feet) and the Clinton Sand (at approximately 3,000 feet) were found productive. These two photographs show some of the earlier drilling in the Somerset area and an oil field camp. The same person mailed both of these photographs within a month of each other in December 1908 and January 1909. The view above reads, "our well at Somerset." The view below reads, "This is our tent at Somerset." (Jeff A. Spencer collection.)

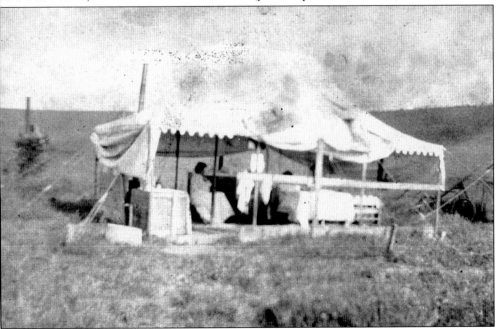

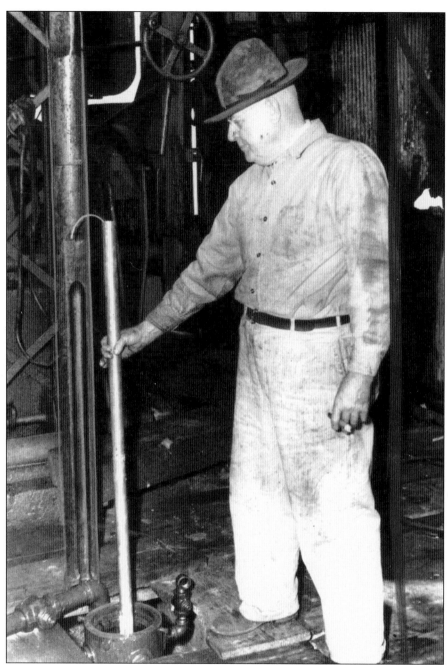

Harry English, a 42-year veteran of the oil field, drops a "jack squib" down the hole of the Garey No. 4 well near Somerset, in 1946. A jack squib is a tin tube filled with dynamite, charged with a blasting cap and a fuse. The fuse is of such length to permit the squib to fall to the bottom of the hole before exploding. If the hole has any fluid in it, sand could be added to the tin tube to make it heavier so it would fall faster through the fluid, whether oil or water. Dropping a sand-laden squib in an empty hole would cause it to fall too fast and it would often fall apart when it hit bottom. If that happened, the cap could be jarred out of position in the stick of dynamite resulting in a poor or no ignition of the main charge. (Grandview Heights Public Library.)

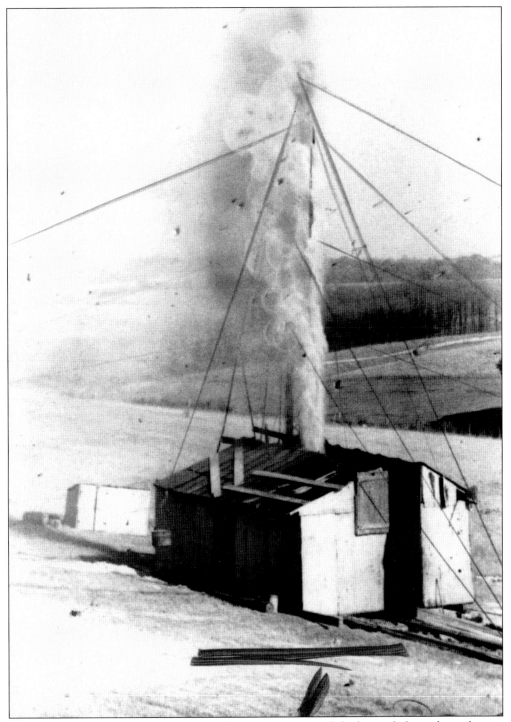

The resulting flow viewed two and a half minutes after English dropped the jack squib onto 80 quarts of nitroglycerine at a depth of 3,000 feet. (Grandview Heights Public Library.)

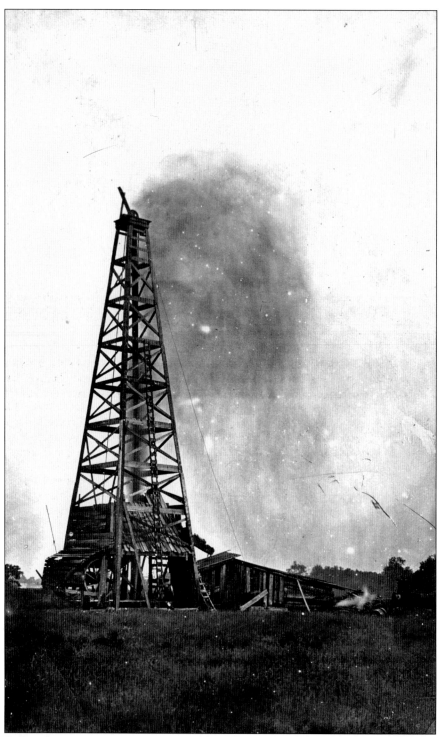

The Chillicothe area, in Ross County, is a bit west of the core area for the early Bremen-New Straitsville oil boom. Oil pools were discovered throughout south-central Ohio as oil companies spread out from the larger fields in search of oil. (Susan Svec collection.)

Six

The Morrow County Oil Boom and Other Ohio Oil Views

December 1959 marked the discovery of oil in southern Morrow County when a well tapped the fluid at a depth of 3,371 feet after drilling through the Clinton and Trenton horizons. Over 17,000 barrels were pumped from this well in the Trempealeau horizon in 1964. Drilling began in earnest in 1961 with over 1,700 drilling permits issued by the state between 1961 and 1964. Oil speculators wildly bid up lease prices. Many wells were dry, but those lucky enough to hit a number of bumps in the Trempealeau made their owners rich. Unfortunately the field was short-lived as the field pressure was rapidly reduced by the closeness of well spacing. The discovery of this field was a good example of modern wildcatting.

Oil and gas exploration and drilling has occurred throughout Ohio and successes are not limited to the major producing boom areas. Drilling has occurred in all counties and has been captured in photographs and postcards. With sustained oil prices, drilling will continue in the Buckeye State for years to come.

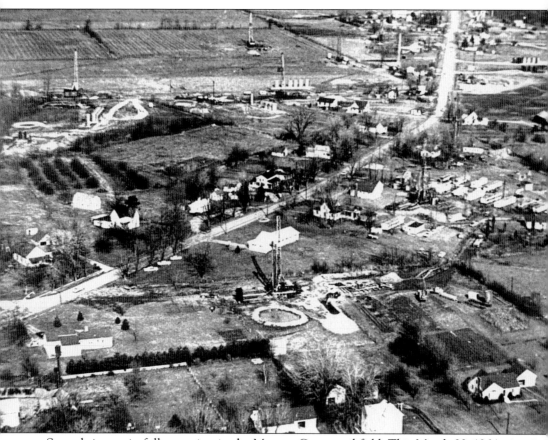

Several rigs are in full operation in the Morrow County oil field. This March 30, 1964, view is looking northeast from Cardington along U.S. Route 42 and is representative of how drilling often occurs during an oil boom. Whether in 1860 or 1960, wells are drilled near towns and in towns. (Ohio Department of Natural Resources, Division of Geological Survey.)

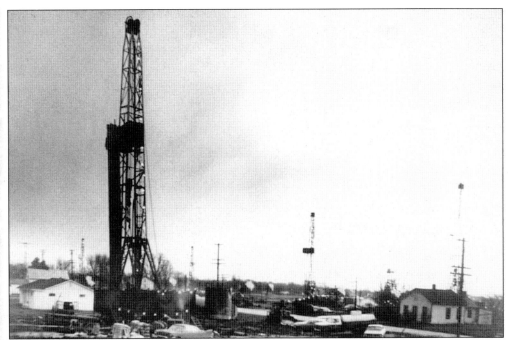

These two photographs are views of working rigs in the Morrow County oil field, around 1964. (Ohio Department of Natural Resources, Division of Geological Survey.)

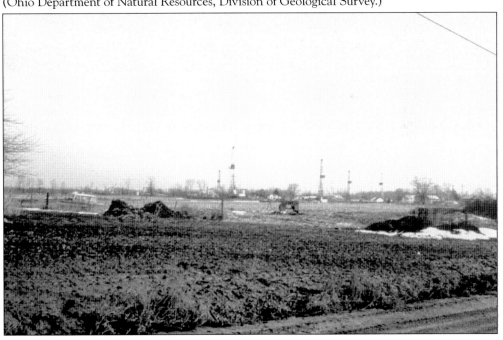

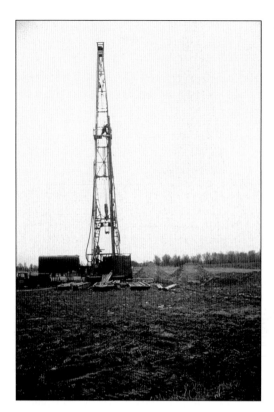

This operating rig was also located in the Morrow County oil field around 1964. (Ohio Department of Natural Resources, Division of Geological Survey.)

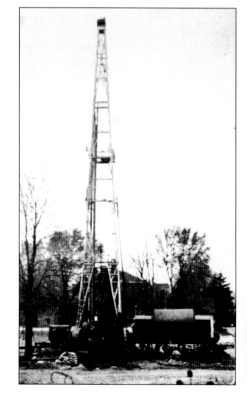

This Morrow County oil rig postcard has the following caption on the reverse, "Even though school was in session, this rotary rig, which occupied the baseball diamond, struck oil behind this Morrow County, Ohio school at Edison." (Jeff A. Spencer collection.)

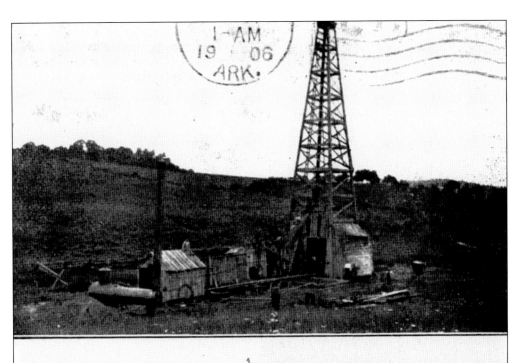

GAS WELL. On the McClellan Farm. First well drilled in Butler (Ohio) Field Drilled June 1905

Wooden derricks and boilers located in Richland County are seen here. The above view is a postcard of the "first well drilled in the Butler (Ohio) Field" in June 1905. The below photograph is from the Mansfield area. Note the boy with the Native American feather war bonnet and toy rifle. (Jeff A. Spencer collection.)

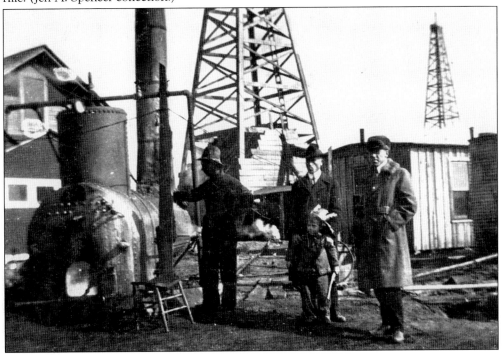

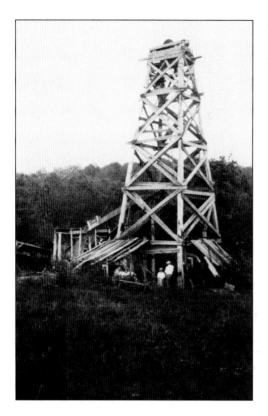

This is a derrick photograph labeled, "oil well on Mt. above Bainbridge, Ross Co., Ohio. Drilling by Mr. Paul [Poul?]." (Jeff A. Spencer collection.)

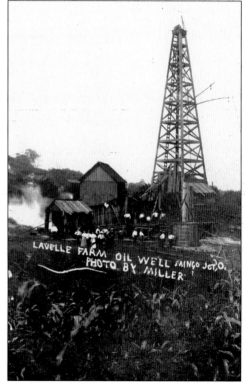

A dozen or so men and women pose for this photograph of an oil derrick on the Lavelle Farm, near Mingo Junction, Ohio, in eastern Jefferson County. This photograph postcard was postmarked in 1908. (Jeff A. Spencer collection.)

Four men pose in front of a Geauga County oil derrick in full operation. The photograph, dated 1909, has the message, "see if you know them four men that is standing their [sic]."(Jeff A. Spencer collection)

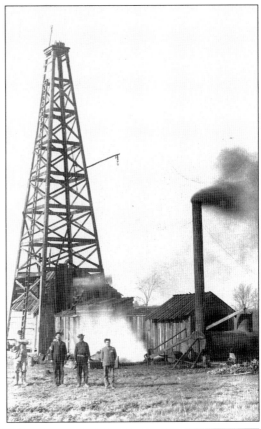

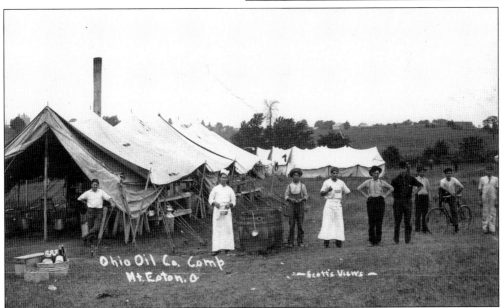

The two men in white aprons are probably cooks at this Ohio Oil Company's camp near Mount Eaton in southeastern Wayne County. There are no obvious oil field workers in the picture or derricks in this undated photograph. (Jeff A. Spencer collection.)

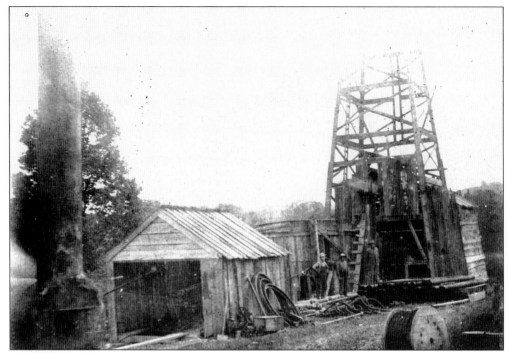

A photograph, from the Mount Vernon area of Knox County, shows a typical view of an oil derrick, boiler (left side of photograph), and three rig workers. (Jeff A. Spencer collection.)

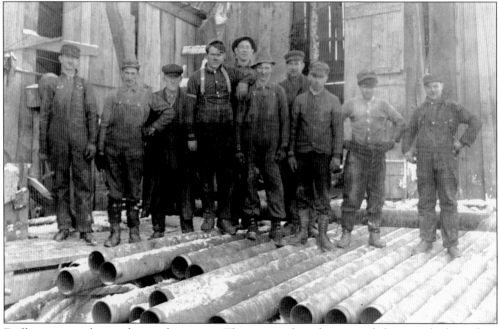

Drilling occurred even during the winter. These snow-dusted pipes and the warmly dressed rig crew are on an Andover derrick in Ashtabula County in about 1912. (Carl Heinrich collection.)

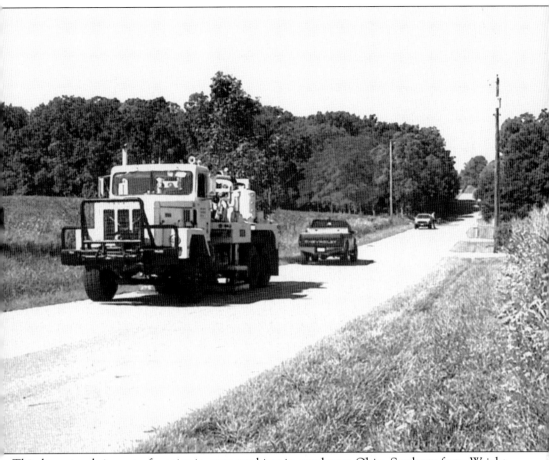

This large truck is part of a seismic crew working in southwest Ohio. Students from Wright State University's Department of Geological Sciences (now the Department of Earth and Environmental Sciences) participated in this 2002 fieldwork. (Paul Wolfe and Bill McIntire, Wright State University.)

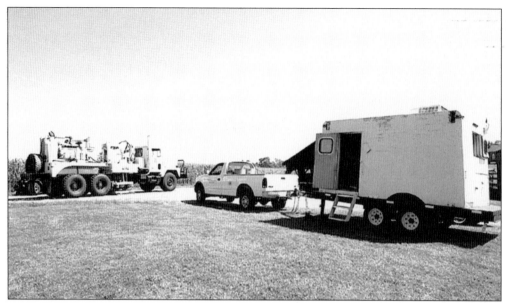

The trailer behind the pickup truck, above, is where the seismic data is recorded. A student is monitoring the equipment in the trailer, below. (Paul Wolfe and Bill McIntire, Wright State University.)

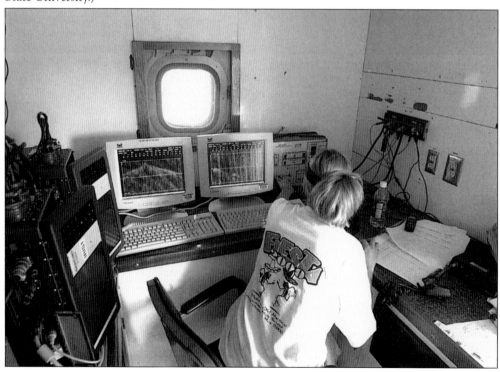

Seven

OIL REFINING AND MARKETING

Numerous refineries were built in Ohio to accommodate the oil discovered during the early boom years. The refineries produced fuel oil and kerosene, the two main petroleum products used during the late 1800s and early 1900s. The Marietta, Ohio-Parkersburg, West Virginia area became a center of oil storage, refining, and transportation for the southeast Ohio oil fields. Likewise northwest Ohio saw rapid growth in tank farm and refinery construction near Lima, Cleveland, Findlay, Crawford (Wyandot County), and Cygnet. Later refineries were built in central Ohio, northeast of Columbus in Licking County.

Early marketing tools included Victorian trade cards. These became a major way of advertising goods and services during the period from about 1880 to 1900. Most trade cards were approximately the size of a three-by-five-inch index card. The front of the card was an advertising picture, usually in color, with the name of the item or service and often a catchy slogan. The back of the card was usually text or testimonials and might have a stamped name and address of a local merchant. Advertising ink blotters were common promotional giveaways in the 1930s and 1940s when everyone used fountain pens. With the introduction of the ballpoint pen in the 1950s, ink blotters essentially disappeared.

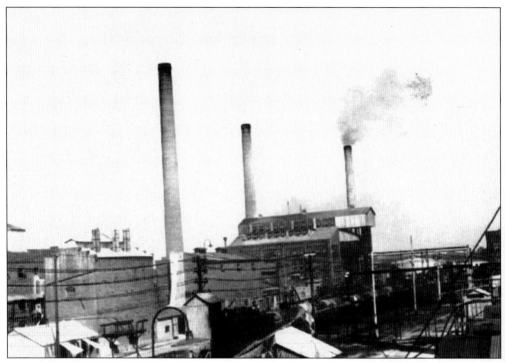

National Refining Company had refineries in Findlay, Marietta, and Coffeyville, Kansas. The Marietta Refinery was acquired in 1906 and closed in 1939. The above view is a c. 1920 view of the refinery. The view below, dated 1928, shows a refining crew. (R. Bergen collection, courtesy of Rick Brown and Ben Eckart.)

In this photograph (undated), 34 workers pose at Marietta's National Refinery. Most of the men are identified on the reverse of the photograph. They are, from left to right, (first row, sitting) Bill Farley, Nate Schuman, Curt Keerps, Ott Young, Bill Boyce, Alvin Parks, Kirchner (?), Bert Lauer, Charlie Harris, John McCoy, John Harris, Ed Shears, Dag Needah, Gid (?) Masters, Bill Pitts, Carl Sprague, Bert Chutes (?), and two unidentified men; (second row) John Gephart, Bill Lacy, Chas Keerps, S. L. Evans, Art Harris, Alexander (?), Shet Pitts, two unidentified, Bob Petty, Allison (?), Everett Law, Orville Caseman, unidentified, and Geo Potter (or Putter). The photograph is stamped O. J. Belt 736 Fifth Street, Marietta, Ohio. (Carl Heinrich collection.)

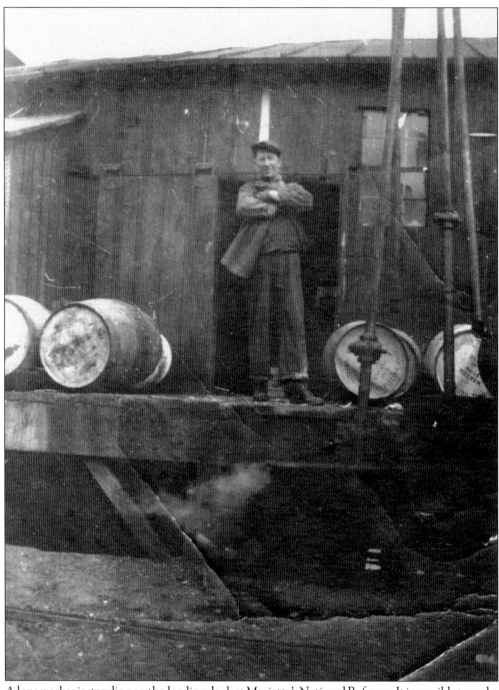

A lone worker is standing on the loading dock at Marietta's National Refinery. It is possible to make out the words *oil*, *National*, and *Cleveland* on one of the barrels. (Carl Heinrich collection.)

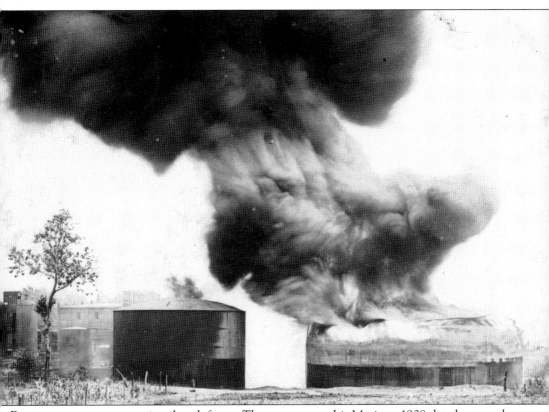

Fires were not uncommon in oil tank farms. The message on this Marietta 1908-dated postcard is, "This is the fire, a 15,000 bbl [barrel] oil tank . . . has burned 24 hours." This collection of oil tanks belonged to the National Refinery Company in Marietta. (Jeff A. Spencer collection.)

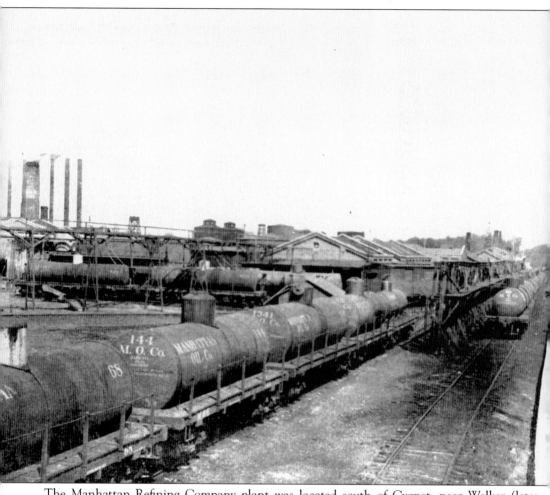

The Manhattan Refining Company plant was located south of Cygnet, near Welker (later renamed Galatea). Welker was surveyed in 1886 and located where the Toledo and Ohio Central Railroad and Baltimore and Ohio Railroad crossed. (Wood County Historical Center and Museum collection.)

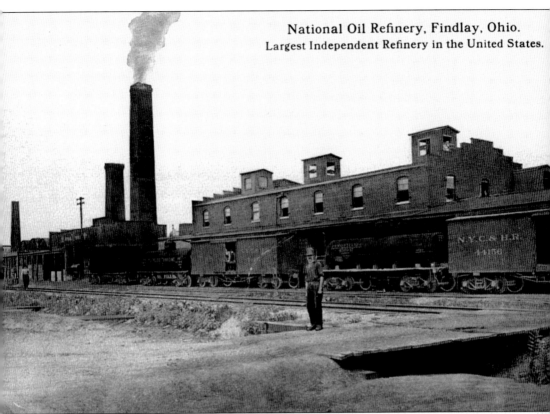

National Oil Refinery, Findlay, Ohio.
Largest Independent Refinery in the United States.

J. I. Lamprecht founded Cleveland-based National Refining Company in 1882 to refine kerosene. Peerless Refining Company constructed a refinery in Findlay in 1887. National Refining Company purchased the refinery in 1896. Several pre-1920 postcards state that the Findlay refinery was the largest independent refinery in the United States. Ashland Oil operated a refinery at the site in the 1960s. (Jeff A. Spencer collection.)

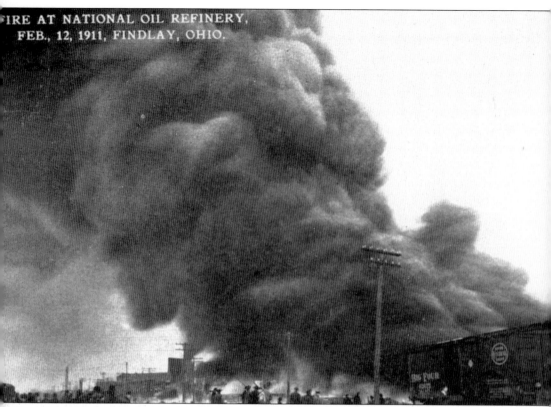
FIRE AT NATIONAL OIL REFINERY,
FEB., 12, 1911, FINDLAY, OHIO.

This fire occurred at the Findlay's National Refinery in 1906. (Jeff A. Spencer collection.)

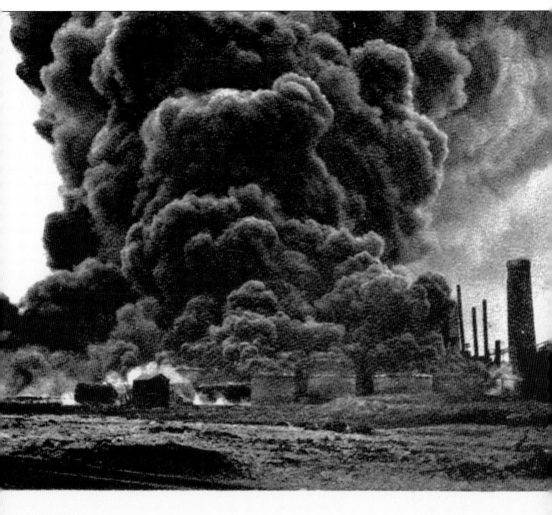

uraing Oil Tanks, National Refinery--Findlay, O.

This fire occurred at the Findlay's National Refinery on February 12, 1911. (Jeff A. Spencer collection.)

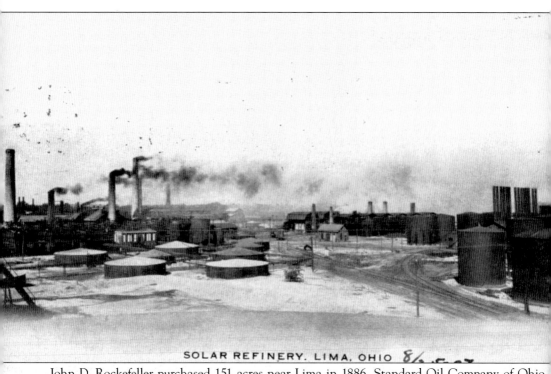

SOLAR REFINERY. LIMA, OHIO 8/₂ ℃ ∾

John D. Rockefeller purchased 151 acres near Lima in 1886. Standard Oil Company of Ohio formed the Solar Refining Company in Lima as a subsidiary. Lima crude oil had high sulfur content and was known as "sour crude." Standard Oil Company built the Solar Refinery and staffed it with engineers and scientists who perfected a technique to remove the sulfur and produce quality fuel oil and kerosene. Standard Oil Company of Ohio acquired Solar Refining Company and the refinery in 1931. Standard maintained an oil tank farm and refinery in Cleveland. By 1873, Standard Oil Company of Ohio owned approximately 80 percent of the refining capacity in Cleveland, which represented nearly one third of the entire United States. (Jeff A. Spencer collection.)

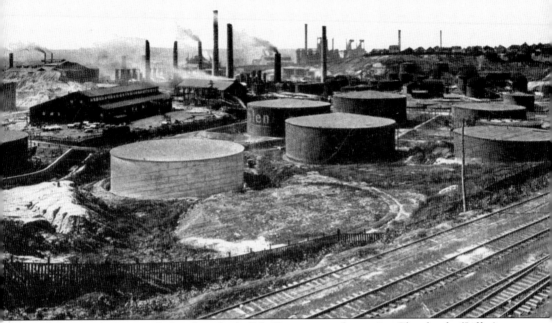

Pictured here is a view of the Standard Oil Company refinery in Cleveland. (Jeff A. Spencer collection.)

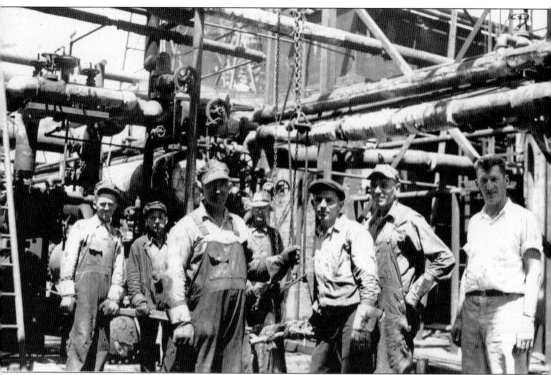

Fletcher Heath and Beman Dawes formed the Ohio Cities Gas Company in Columbus. The company became Pure Oil after a large oil discovery in 1914 near Cabin Creek, West Virginia. The company eventually operated refineries in Ohio, West Virginia, Oklahoma, and Texas. This photograph is labeled "Granville, Ohio" and is probably from the old Pure Oil Refinery in Licking County. (Jeff A. Spencer collection.)

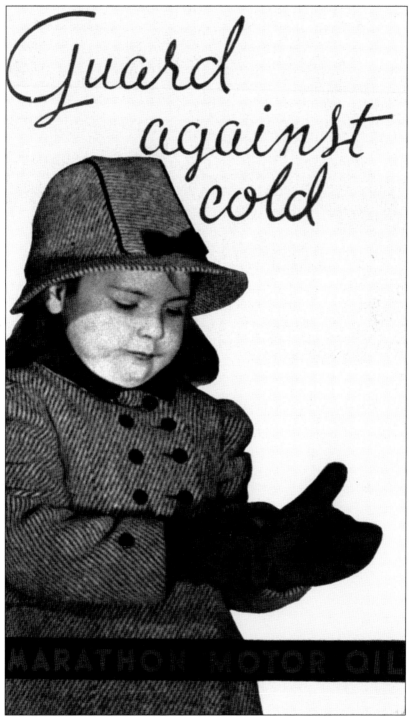

A Marathon Oil ink blotter depicts a little girl preparing for a winter day. The advertisement is for the company's motor oil, which guards cars against the cold. Vintage ink blotters are highly collectible and there are many examples of oil company blotters from the 1930s and 1940s. (Jeff A. Spencer collection.)

Engine oil was a common refined petroleum product advertised on early Victorian trade cards. Many cards had detailed product descriptions or local dealer contact information on the reverse (this one does not). (Jeff A. Spencer collection.)

Zone Oil Company of Cleveland used this image of Henry Clay's Ashland estate in Lexington, Kentucky, to advertise their "refined oil for refined cars for refined people." (Jeff A. Spencer collection.)

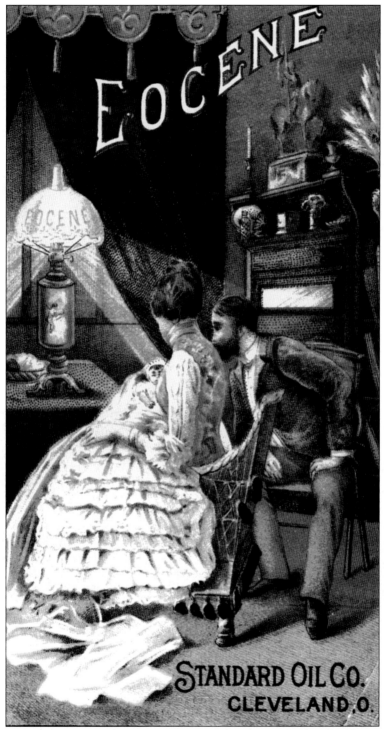

Eocene oil was a brand of kerosene used for home heating and lighting. Standard Oil Company of Ohio produced the product in their Cleveland refinery. Note the lamp with the brand name on the shade. (Jeff A. Spencer collection.)

EOCENE

Specially Manufactured for Family Use.

THE unparalleled success attending our efforts to place before the public an oil of the **VERY FINEST ILLUMINATING POWER**, together with the generous appreciation of our patrons, has prompted us to offer

—SPECIAL INDUCEMENTS—

to our friends for the purpose of permanently establishing *"EOCENE"* as the unrivalled brand of oil for **FAMILY USE**.

Careful analysis has demonstrated that we are enabled to produce the highest possible grade of illuminating oil,

The backs of Victorian trade cards commonly contained the sales pitch for the product. Trade cards faded from use in the early 1900s when magazines became a more popular and cost effective means of advertising. (Jeff A. Spencer collection.)

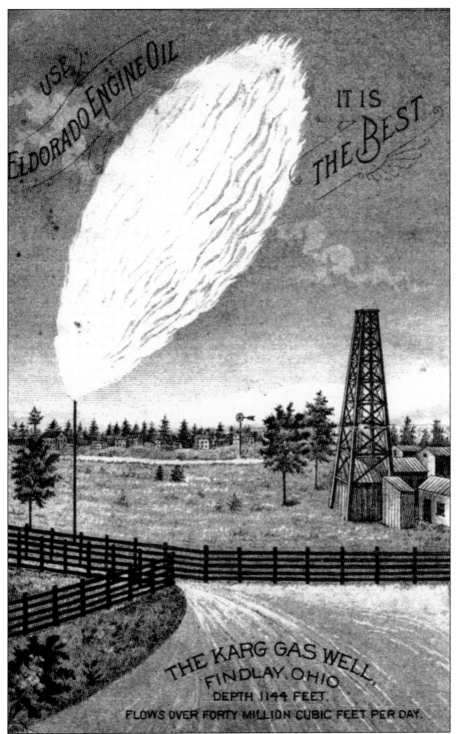

The great Karg gas well of Findlay advertises Eldorado engine oil. The engraving on the front of the trade card does not accurately depict the setting for the Karg well, located along the bank of the Blanchard River. (Jeff A. Spencer collection.)

A local dealer's name and town (Fort Seneca, Ohio) is printed on the reverse of this trade card. In the early part of the 20th century, people enjoyed collecting trade cards and mounting them in albums. In recent years, Victorian trade card collecting has again become popular. (Jeff A. Spencer collection.)

BIBLIOGRAPHY

Camp, Mark J. *Roadside Geology of Ohio*. Missoula, MT: Mountain Press Publishing, 2006.

Geological Survey of Ohio. *The Bremen Oil Field*. By J. A. Bownocker. Bulletin no. 12. Springfield, 1910.

Geological Survey of Ohio. "The History and Development of the Macksburg Oil Field." In *Economic Geology*. By F. W. Minshall, 443–475. Vol. 6. Columbus, 1888.

Geological Survey of Ohio. *The Occurrence and Exploitation of Petroleum and Natural Gas in Ohio*. By John Adams Bownocker. Bulletin no. 1. Springfield, 1903.

Maslowski, Andy. "Mecca: Ohio's First Oil Field." *Timeline* 5, no. 5 (1988): 14–20.

McKain, David L., and Bernard L. Allen. *Where It All Began*. Parkersburg, WV: David L. McKain, 1994.

Miller, E. Williard. "Petroleum in Southeastern Ohio." *Ohio Journal of Science* 43, no. 3 (1943): 121–134.

Overby, W. K., and B. R. Henniger. "History, Development, and Geology of Oil Fields in Hocking and Perry Counties, Ohio." *AAPG Bulletin* 55, no. 2 (1971): 183–203.

Sneed, Judith L. "The Lost History of Ohio's Grand Reservoir Oil Boom." *Oil-Industry History* 6 (2005): 49–53.

Spence, Hartzell. *Portrait in Oil*. New York: McGraw-Hill Book Company, 1962.

Spencer, Jeff A., and Judy Robinson. "The Thorla-McKee Salt Works and Oil Wells and the Macksburg, Ohio Oil Booms." *Oil-Industry History* 8 (2007).

Wickstrom, Lawrence H., and John D. Gray. "Boom Towns: Oil and Gas in Northwestern Ohio." *Timeline* 11, no. 6 (1994): 2–15.

www.dnr.state.oh.us

www.enarco.com

www.petroleumhistory.org

ACROSS AMERICA, PEOPLE ARE DISCOVERING SOMETHING WONDERFUL. *THEIR HERITAGE.*

Arcadia Publishing is the leading local history publisher in the United States. With more than 3,000 titles in print and hundreds of new titles released every year, Arcadia has extensive specialized experience chronicling the history of communities and celebrating America's hidden stories, bringing to life the people, places, and events from the past. To discover the history of other communities across the nation, please visit:

www.arcadiapublishing.com

Customized search tools allow you to find regional history books about the town where you grew up, the cities where your friends and family live, the town where your parents met, or even that retirement spot you've been dreaming about.